Your Mountain Is Calling

RACHEL ANNE RIDGE

PHOTOS BY TOM RIDGE

HARVEST HOUSE PUBLISHERS
EUGENE, OREGON

Cover and interior design by Studio Gearbox

For bulk, special sales, or ministry purchases, please call 1 (800) 547-8979.
Email: Customerservice@hhpbooks.com

M This logo is a federally registered trademark of the Hawkins Children's LLC. Harvest House Publishers, Inc., is the exclusive licensee of this trademark.

Your Mountain Is Calling
Text © 2022 by Rachel Anne Ridge
Photography © 2022 by Thomas Ridge
Published by Harvest House Publishers
Eugene, Oregon 97408
www.harvesthousepublishers.com

ISBN 978-0-7369-8419-5 (hardcover)
ISBN 978-0-7369-8420-1 (eBook)

Library of Congress Control Number: 2022931600

Printed in China

22 23 24 25 26 27 28 29 30 / RDS / 10 9 8 7 6 5 4 3 2 1

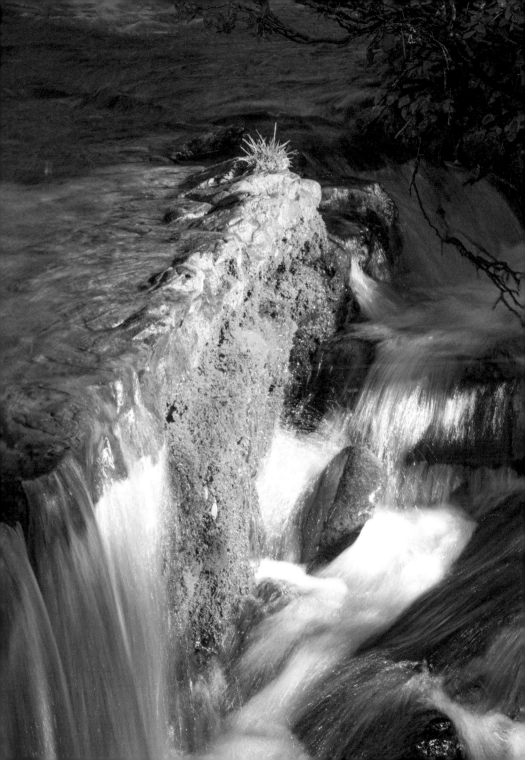

Contents

Introduction: Finding God in Untamed Places 6

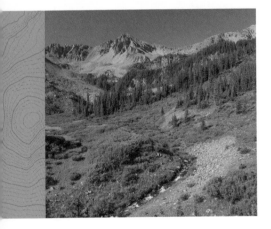

Awe ... 11
Hope ... 15
Stillness 19
Liminal 23
Calling 29
Fire .. 33
Awry ... 37
Flow .. 41
Examen 47
Failure....................................... 51

Resilience 55
Pathways 59
Abandoned.............................. 65
Immanence.............................. 69
Shelter 73
Spacious................................... 77
Essentials................................ 83
Reflections 87
Burdens 91
Wonder 95
Healing 101

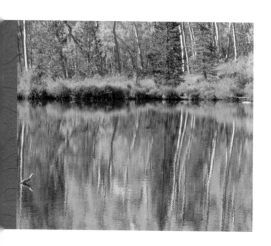

Familiarity 105

Ephemeral 109

Ache 113

Pilgrimage 119

Praise 123

Darkness 127

Goodness 131

Grief 137

Free .. 141

Perspective 145

Grace 149

Accepted 155

Rest .. 159

Mystery 163

Risk .. 167

Undaunted 173

Resilience 177

Present 181

Thaw 185

Notes .. 191

About the Authors ... 192

Introduction

Finding God in Untamed Places

As the small aircraft begins its descent to the Kahiltna Glacier, the mountaineers onboard crane to see the mountain that seemed to summon them from all parts of the globe: Denali. With a grandeur far beyond their imaginations, the legendary peak dominates the entire frozen landscape, a sight that causes the group to fall silent. They'd each dreamed of this moment, some of them for years, in which they would finally encounter the tallest mountain in North America. Translated as "the High One," the Native People's name for her befits her stature and overwhelming presence in the Alaskan range. A couple of the climbers wipe tears from their eyes.

Disembarking the plane, they pause on the glacier for a moment to take in the wonder. The peaks of Hunter, Foraker, and Kahiltna Dome, immense mountains in their own rights, are but foothills to the great Denali. Alpine air, carrying ice crystals blown from the surrounding peaks, glitters all about them.

"I'm not a religious person," says one of the climbers, almost to himself. "I don't even really believe in God." He pauses and then whispers, "But this is truly a spiritual experience."

There is something about mountains.

Whether it's their awe-inspiring grandeur, their rugged timelessness, or their untamed presence, mountains have called to humankind with a wordless power. Mesmerizing, captivating, overwhelming, they invite us into a state of awe that is transcendent and deeply spiritual.

They invite us to find God in the untamed places.

Sir Francis Bacon (1561–1626) echoed early church philosophy when he stated, "God has, in fact, written two books, not just one. Of course, we are all familiar with the first book he wrote, namely Scripture. But he has written a second book called creation."[1]

The book of creation, its heights and depths still being explored, continues to reveal a Creator in ways a printed page cannot. Here we experience a wonder and awe that opens us to a God not contained by human words or constructs.

When King David, overcome by a desire to honor God, wanted to build a grand temple for Him, the Lord said: "Heaven is my throne, and the earth is my footstool. Where is the house you will build for me? Where will my resting place be?" (Isaiah 66:1). In other words, "What could you possibly build that would contain Me?"

Is it any wonder that so many divine encounters happen in the mountains? Jesus Himself was known to seek out the solitude of mountains and hillsides to meet with His Father. It was in these spaces that He found revelation, communion, and direction.

We are honored to share some of our favorite photographs and devotions from our own time spent in the mountains. Our prayer is that you will be inspired to make your own mountain pilgrimages to encounter God in the untamed places.

He calls us, through His incredible creation, to experience Him.

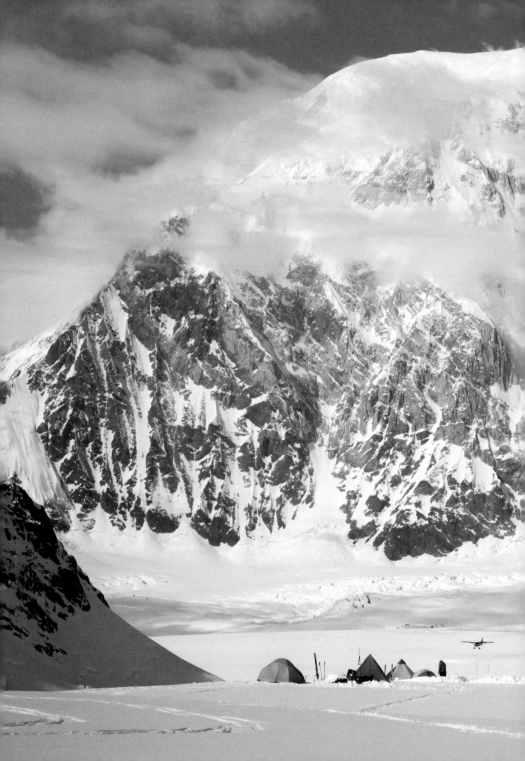

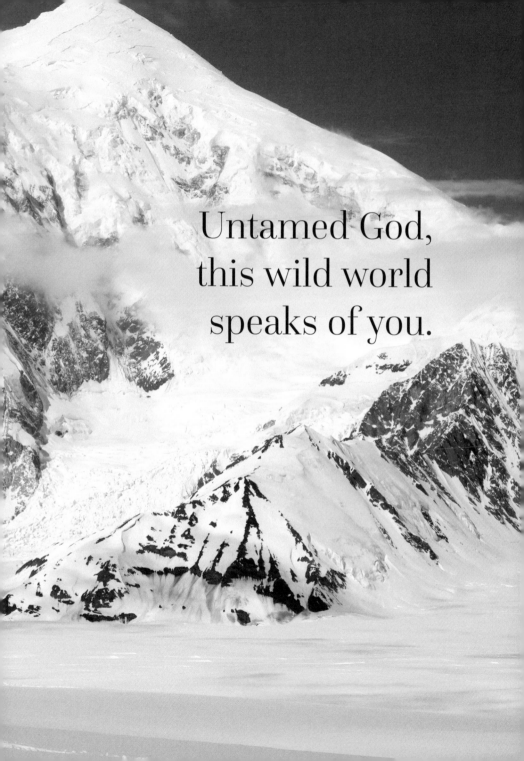

Untamed God,
this wild world
speaks of you.

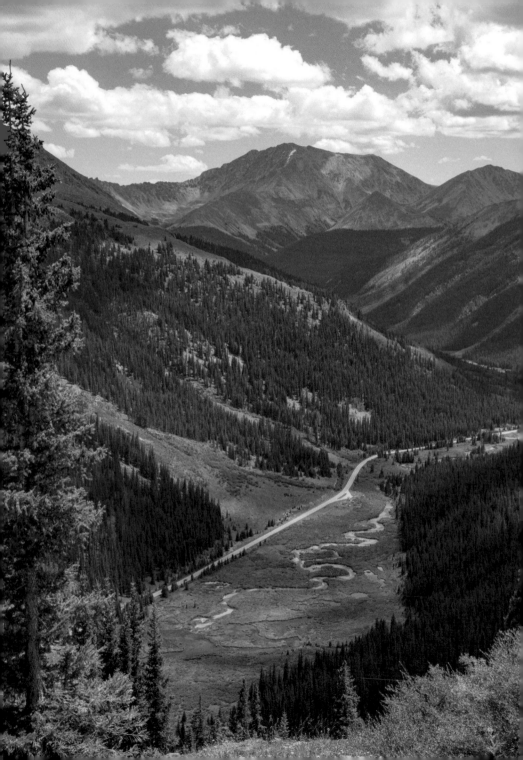

Awe

The mountains do indeed call.

They beckon you with unfolding vistas around every turn as you drive from the foothills into the higher altitudes of the range. Your soul shifts gears as the road curves higher, following a rushing river that sparkles in the afternoon sun. There is a tug on your heartstrings to experience everything this rugged landscape has to offer.

From somewhere, a fragment from the Narnian tales you read as a child slips into your mind: an invitation. *Come further up, come further in.*

It's from C.S. Lewis, *The Last Battle*. "I have come home at last! This is my real country! I belong here. This is the land I have been looking for all my life, though I never knew it till now. . . . Come further up, come further in!"[2]

A metaphor, perhaps, for the spiritual journey you are on. It's a journey that's kept you awake at night and found its way into your thoughts as you go through your day.

It's a quest for home and for belonging. It's a quest for God Himself.

Who is this God? And how can I know Him more deeply?

The mountains feel like the right place to spend some time right now. Away from the busyness of work and obligations, away from man-made structures and schedules, and into a wild cathedral of snowcapped peaks that anchor a canopy of stars. Though the landscape is unfamiliar, a sense of *home* pervades your senses.

Finally you see a pullout for vehicles where travelers can stop and take in the view. The road has been winding for what feels like hours, and here near the top of the pass is a place to look out over the range you've traversed.

You get out and stretch your legs and then find yourself at the guardrail in utter amazement. You can see for miles.

Peak after peak, ridge after ridge. The air is cooler, thinner, and clouds have settled into the pockets and folds of what looks like a wrinkled mass of land heaped before you.

From here, the road below looks like a tiny pathway with miniature cars traveling it. The busyness of your everyday world feels far away, and with it the pressures and concerns that seem to fill every

"I have come home at last!" – c.s. LEWIS

spare moment. This view, these mountains, this air, this inexplicable calling—and suddenly you know: You have come home . . . to *awe*.

Awe is the tent of childhood wonder you once lived in, found comfort in, and then packed away with the rest of your outgrown items. In a singular moment of clarity, you know something about this God you're seeking: The One who brought such an incredible world into existence invites us home to live and move and have our being in Him.

God did this so that they would seek him
and perhaps reach out for him and find him,
though he is not far from any one of us.
"For in him we live and move and have our being."

ACTS 17:27-28

Hope

Towering peaks pierce the pale morning sky. The sun, lightly caressing their rugged faces, ignites the treetops and outcroppings of rocks and cliffs as it begins its ascent into the young sky. You watch the ridgeline as it awakens to a new day, its shades of pink, gray, green, and brown deepening into a rich tapestry of shapes and colors. Steam curls around the edge of your coffee cup and disappears, and you listen to a downy woodpecker that has already begun his day's work on a distant hardwood tree. *Rat-a-tat-tat-tat.* It echoes through the forest like a reveille, signaling the time to all the woodland creatures.

The day ahead is filled with a hike and hope.

It's a sacred moment, the time in between.

It's the time between planning and execution, between anticipation and realization, between longing and revelation. It's the same tension between hope and disappointment, or ache and joy. As dawn breaks across the world, there is no guarantee that the outcome you seek will be the outcome you receive.

You feel a shiver of anxiety, yet you inhale a sense of expectancy.

Pause.

Hope.

You are alive in the dewdrop of unknowing.

Plans in the mountains must be held loosely. What looks like a perfect hike on a map may turn out to be much more difficult than you imagined. You may believe you've thought of everything you need for the day's activity only to find you've forgotten an essential item and

must change course. Afternoon thunderstorms can appear without warning and create situations you didn't anticipate. A stream ahead may be unpassable. A mountain vista may be too stunning for you to do anything more than cancel the rest of the hike and stay to appreciate the view. Things can change on a dime.

It's so much like life itself.

We can make a plan and chart our course, but until we begin, we simply cannot know what the results will be. Sometimes that "not knowing" keeps us from taking the first step. We remain stuck back at the lodge, unable to risk disappointment or failure. Other times, we find ourselves playing it safe, taking routes that are predictable, enjoyable but forgettable, failproof. Or we create a plan and vow to stick to it no matter what happens, and so we miss the thrill of seeing where serendipity (or God-sized interruptions) might take us.

Today as you finish your coffee, you are open to whatever happens on the trail. You pack extra water and snacks, check your gear for first aid supplies, throw in a rain jacket, sunscreen, and a journal—because you don't want to forget the journey that calls to you today.

Proverbs 16:9 says, "A man's mind plans his way [as he journeys through life], but the LORD directs his steps and establishes them" (AMP).

What will your endeavor hold? Only God knows for sure.

And so you pause.

You hope.

And you begin.

The LORD directs the steps of the godly.
He delights in every detail of their lives.

PSALM 37:23 NLT

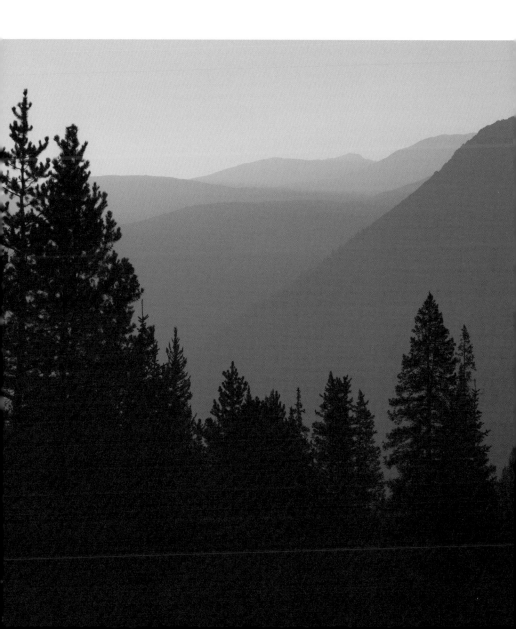

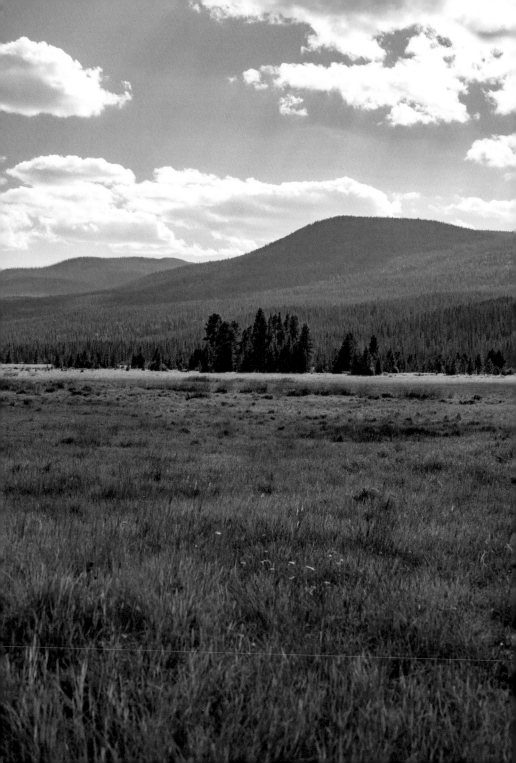

Stillness

You weren't prepared for the stillness.

You know it's what you were hoping for, what you told your friends and family that you needed, and what drew you to this mountain meadow today.

"I need a break from all the busyness," you said.

But it is . . . very still.

Too still.

It feels uncomfortable, this sitting, this waiting. This doing nothing. It's so unproductive.

Your hand itches to take out your phone, check your email, check the weather, look at the headlines. It's what you do when you find yourself sitting in a doctor's office, or at an airport, or in between meetings. The constant stimulation is a habit, one that feels comforting and familiar. You are used to making the most of every minute—and even "downtime" consists of activities and entertainment.

Your mind isn't accustomed to this . . . this absence of activity.

But this is why you are here, and you accept the discomfort of stillness.

Stillness takes practice, they say, and you are a beginner.

Gradually, you feel your breathing slow, and you become aware of the buzzing of bees as they find nectar in the flowers that bob their heads in the breeze. There is a faint *shhhh* of tall grasses and the murmur of a stream in the distance. The trees at the edge of the meadow erupt in quiet applause as a gust of wind causes them to clap their

leaves together in delight. *Joyous*, you think, and you dig your feet into the dirt—the very dust from which you came. Just then a bird alights on a twig in front of you, cocking its head as if to inquire about your well-being.

"I am learning to be still," you tell her.

As if prompted by this little warbler, you turn it into a prayer: *God, help me to be still so I can know You.*

Psalm 46:10 says, "Be still, and know that I am God; I will be exalted among the nations, I will be exalted in the earth."

I'm trying, Lord; I'm trying.

In the discomfort of moments like these, we realize our addiction to busyness and activity and to our digital screens. We are unsettled by our inner selves, the ones we try to ignore, the ones we disguise with our polished, accomplished exteriors. As beginners in the practice of stillness, we can find it excruciating, even in a beautiful meadow, to quiet our thoughts and slow our breathing. Our bodies want to leap up and begin to hike so we can feel like we accomplished *something* today. Our true self squirms in the sudden nakedness of vulnerability.

And yet.

The stillness draws us in with a promise of a different way of being. To be still, to be in tune with our surroundings, to know God, to be at peace . . . this is what our soul longs for. We must free ourselves from the chains of productivity, from the fear of who we are without the trappings—and find untethered spaces where our hearts can open to the wonder of a God who inhabits this stillness.

We cannot get there any other way.

In quietness and confidence is your strength.

ISAIAH 30:15 NLT

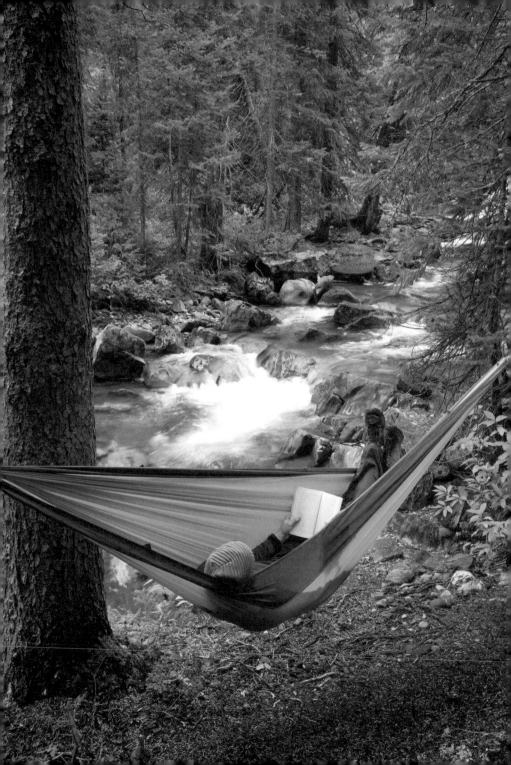

Liminal

The hammock sways with the gentle motion of your foot as you slowly flex your ankle and release it.

Flex.

Release.

Flex.

It's just enough movement to shift the shadows of tree branches on your face and create intricate patterns on the inside of your closed eyelids. You feel the air on your skin—warm, then cool, warm, then cool—as you drift between sun shafts and shadows.

Why don't I hang my hammock up at home in the backyard? Why do I wait until I'm in the mountains to do something so simple yet so relaxing?

You know why.

Your schedule has no margin for gentle swaying.

Life comes toward you at breakneck speed, and there is simply no way you could justify watching shadow branches on your eyelids when there is scarcely time to catch your breath.

It's all good; it's all to be expected.

You've got responsibilities. A position you've worked hard for. People who depend on you.

Your calendar is filled to the brim, and you're not complaining.

It's just that hammocks are for vacations, which are planned and executed for maximum relaxation within the confines of start and finish dates on a calendar. Hammocks are for the free afternoon you've scheduled until 4:00 p.m.

Is it getting close to four? Where is my watch?

The hammock gently rocks.

Leaves ruffle overhead. A breeze moves through the branches with a quiet drawl. *Stay here a little longer*, it seems to implore.

It's hard to resist a breeze that flirts with your shirt collar, so you sink deeper into your fabric cocoon.

Suspended as you are—between two tree-pillars, with no real idea of the time—it feels like a revelation. It's an opening into a God experience that doesn't fit into neat boxes, one that suggests that the world of the Spirit is found in liminal spaces.

It's in the margins of life that we discover infinite possibilities, intricate patterns on eyelids, and respite from predictability. There is a weightless swaying that feels like a mother's soft embrace, an invitation to rest in the comfort of unknowing.

Stay here a little longer.

There are whispers from above.

The God who formed these mountains is not contained within Sunday mornings or limited to a time slot called Devotions that gets checked off before Workout and after Emails. He does not conform to our schedule or even to our finite ideas about Him.

His presence—like wind—slips outside the lines, hangs in the air, moves in the pauses. He waits, suspended in the openings, to sway our moorings and rock our worlds with a still, small voice.

After the earthquake there was a fire,
but the LORD was not in the fire.
And after the fire there was
the sound of a gentle whisper.

1 KINGS 19:12 NLT

My heart has heard you say, "Come and talk with me."
And my heart responds, "LORD, I am coming."

PSALM 27:8 NLT

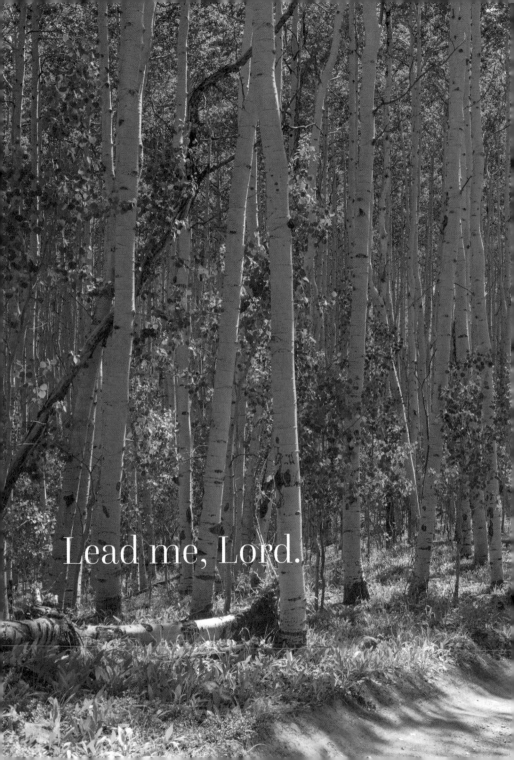

Lead me, Lord.

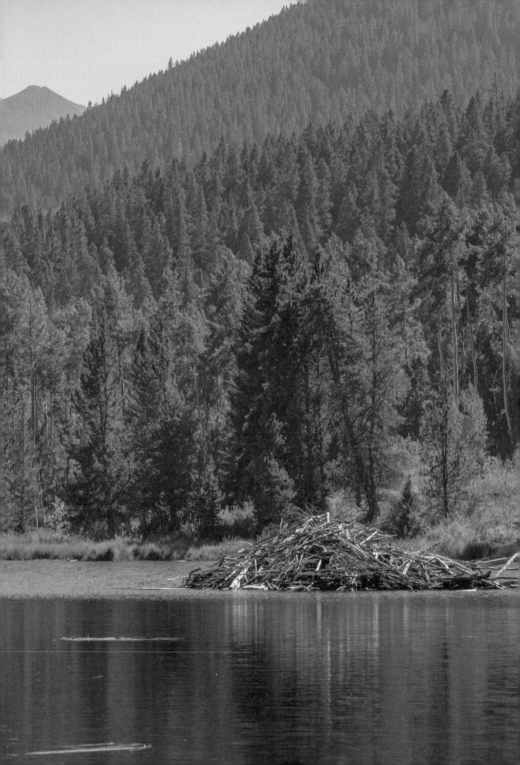

Calling

It's the stunning architecture that first catches your eye. At home in the high mountain setting, the lodge's use of natural elements has an organic feel that captures the aesthetic of the outdoors without competing with it. It is coupled with a matching dam that spans a waterway and creates new habitats for birds and wetland creatures with its ingenious design. Possessing hidden entrances and exits for the family to come and go, it maximizes their work and home life into a seamless work-life balance.

The architects and engineers of this incredible lodge?

A pair of beavers.

Two industrious creatures, who are now making their way across the water at sundown, have not only built a home for their brood of kits but have created a whole ecosystem that benefits the entire area.

You stand near bulrushes at the edge of the main pond, which is now a reflection of pink and yellow clouds, and admire this ecological marvel created by this semiaquatic duo. You find yourself wishing you could shake their hands . . . or at least tip your hat to their ingenuity and hard work.

The beavers are doing what they were born to do—the work they were created for—and it strikes you as . . . well, a sacred endeavor.

Oh, to be doing what I, too, was created to do.

Your heart skips a beat at the thought.

As you watch the beavers begin their evening ritual of scouting for suitable trees and branches to put the finishing touches on their lodge,

"May I have the courage today
To live the life that I would love,
To postpone my dream no longer
But do at last what I came here for
And waste my heart on fear no more."
- JOHN O'DONOHUE [3]

it occurs to you that they enjoy a singular focus on their work. Cutting trees, engineering waterways, bringing food to their young—they tirelessly build something that lasts, something with impact, something that serves the greater community while providing for themselves. You can't exactly say you're jealous of those beavers, but inside you sense a longing to have that kind of clarity and focus in your own life.

What is my calling, and how can I do the meaningful work I am created for in this world?

You know instinctively that these are important questions.

This is a holy moment.

The sun is sinking now, dipping steadily behind the surrounding hills. You fill your lungs with the marshy air. There has always been a calling deep within your soul, a sense that you are made for something more—and you know it. Though you've tried to ignore it by filling your life with achievements and accomplishments, this awareness has never really gone away. It has lingered in the bulrushes at the edges of your imagination, which is now ablaze in color and tense with excitement. This thing you are meant for—this work, this calling—is no longer something to be put off.

You are on a mission to make it a reality.

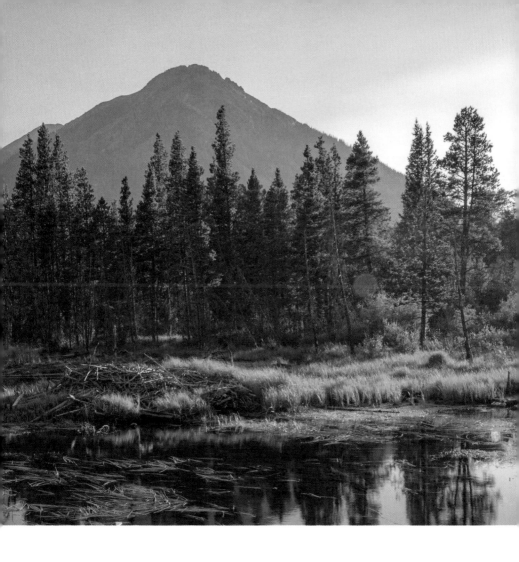

I chose you and appointed you so that you might go
and bear fruit—fruit that will last—and so that whatever
you ask in my name the Father will give you.

JOHN 15:16

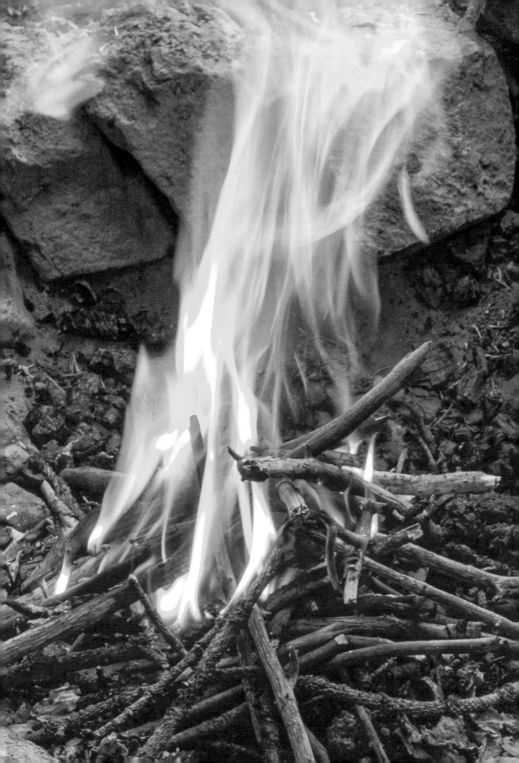

Fire

There is an art to building a good campfire.

To begin, you must find a suitable spot: not too close to trees or brush that could ignite into a forest fire. The ground should be free of grass and weeds, and large rocks or boulders might be placed around the campfire area to contain it.

Next you gather tinder: dried mosses, grass, leaves, or paper that can serve as the nexus for the fire. Once the tinder material is placed loosely together in the center, you prop sticks or small twigs, teepee-style, over the tinder. This is called the kindling, and you take care to make sure there are spaces—particularly in the direction of the incoming wind—so that enough oxygen can reach the tinder inside. You love the feeling of satisfaction when the tinder ignites the kindling. With some gentle blowing, you coax the sparks into a small flame.

Now you place larger pieces of wood around the kindling—still in teepee style—which will serve as the main fuel for the fire. You'll let these get to full-burn stage before adding the final logs.

Learning how to build a campfire—stacking the layers of tinder, kindling, and fuel—is a task you take some good-natured pride in. It's an essential skill for outdoor living, one that has been passed down for millennia—and you are a bearer of this tradition. Our modern gas fireplaces, which turn on with the flip of a switch, are convenient and hassle-free—perfect for our busy indoor lives. But out here in the mountains, there is no substitute for real logs that smell of cedar, pine, and birch as they burn brightly within the circle of boulders and

illuminate the faces of family and friends.

Sitting around a good campfire, one with hot coals for nestling a Dutch oven filled with the evening stew or for browning marshmallows until perfectly crispy on the outside and tender on the inside, is both comforting and satisfying. It is the perfect setting for telling stories, sharing a meal, and simply watching the fire crackle under the stars.

It brings to mind how our ancient Scriptures were written near the warmth of fires. We can imagine scribes bending over their papyrus by candlelight, a fire in the hearth to warm a stone room. Or the people of Israel passing down their oral traditions to their children as the sparks drifted toward the Milky Way and sleepy heads nodded in blankets.

Fire warmed God's people as they camped at the base of Mount Sinai and waited to enter their Promised Land. Fire stood as a pillar to protect them—God's presence was never far.

Exodus 13:21 says, "The Lord went before them by day in a pillar of cloud to lead them along the way, and by night in a pillar of fire to give them light, that they might travel by day and by night" (esv).

Later, flames of fire appeared over the heads of the disciples as the Holy Spirit was given at Pentecost.

Holy fire, its significance sometimes lost on our modern sensibilities, evokes in us a sense of provision and well-being, of comfort and light. It reminds us that God's presence is essential for survival, sustenance, and community.

You might even say the story of God's presence was born and spread around a good campfire.

They said to each other, "Didn't our hearts burn within us as he talked with us on the road and explained the Scriptures to us?"

LUKE 24:32 NLT

Awry

"It's not an adventure until something goes wrong," says your friend with a wink. A veteran outdoorsman who plans each excursion into the mountains with meticulous detail, he knows that even the best-laid plans can fail. You settle in as he launches into a story.

On one memorable trip, he found the perfect spot for a family campsite: a level clearing on an embankment above a small mountain lake. They pitched their tent, hung a clothesline, made a campfire, and ate a delicious dinner under the stars. Tucking into their sleeping bags that night, they marveled at the inky darkness of a sky without light pollution and a quiet so complete that their heartbeats hammered in their ears.

A sudden crack of lightning pierced the silence, so close it made the hair on their arms stand on end. The sky let loose with a deluge of rain as they huddled in the tent, thankful for the shelter . . . until they realized water was seeping into their sleeping bags. The tent was pitched right in the middle of a runoff stream that channeled the coursing water down the hillside into the lake.

Your friend laughs as he recalls the memory. "Yep, 'best-laid plans' did not include digging a moat around the tent at midnight, getting soaked to the bone as lightning struck all around us."

Wet, tired, cold, and discouraged, they packed up their soggy camp at the first sign of morning light and hiked out—to a hotel. Warmed and freshly showered, they finished the final days of their adventure with restaurant dining and shopping in a charming mountain village.

"It was a special kind of unexpected delight," he says. "I've still got the hat I bought in the gift shop!"

Each of our stories is filled with plans gone awry. We are reminded of Joseph, a man who was sold into slavery by his brothers and endured hardships that included being falsely accused of a crime and thrown into jail. But in the end, it was God who watched over each wrinkle in the plans to bring about the salvation of Egypt and Joseph's entire family.

Genesis 50:20 says, "You intended to harm me, but God intended it for good to accomplish what is now being done, the saving of many lives."

When life doesn't go as you've planned, you can be confident that God will redeem it in unexpected and beautiful ways.

We can make our plans,
but the LORD determines our steps.
PROVERBS 16:9 NLT

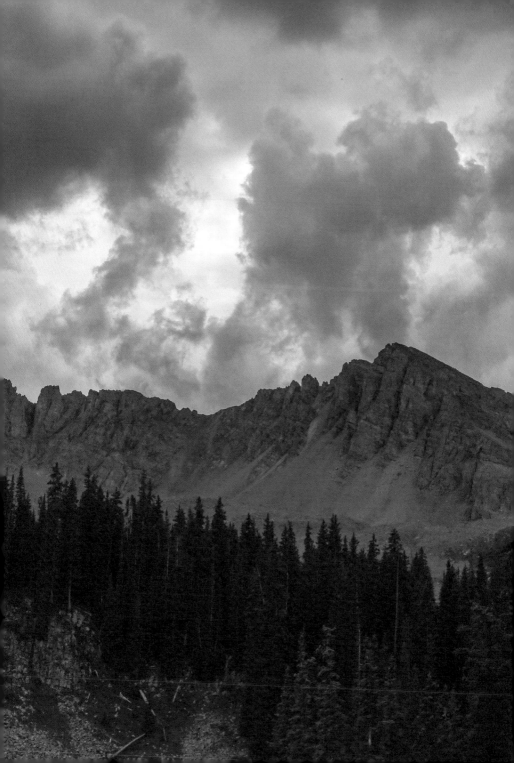

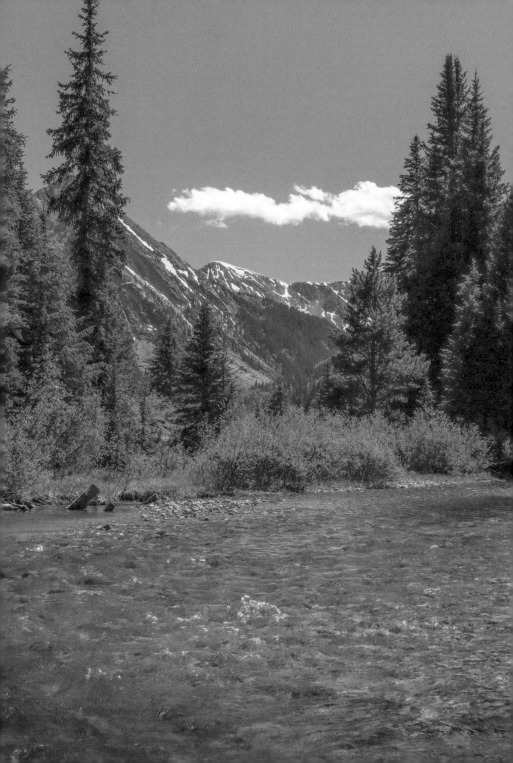

Flow

The wide stream meanders through a high mountain valley that's dotted with cottonwood trees and peachleaf willows along its banks. Fertile fields spread out on both sides, offering sweet wheatgrass for the small herds of cattle lounging near fences in the afternoon sun. You have a perfect spot to sit and enjoy the fresh air while you work on a list of goals for the coming season. The gentle flow of the water over its bed of river rocks sounds almost like rain on a rooftop, lulling you into a thoughtful mood as you think about what is important to you in your work.

It's not hard to admit that staying motivated has been a challenge. You've wondered where your passion for something you once loved has gone. You've had to push yourself to complete tasks that should be easy to do.

You watch a leaf drift by on the water, bobbing over the ripples and ushered along by the current. It moves effortlessly, almost joyfully, down the river.

I miss being in the flow, you think.

That's what it is.

The thing you're missing is called "the creative flow." It's the sweet spot, the marriage of inspiration and meaningful work. Not limited to creative work, the flow is what every artist, musician, athlete, minister, and mountain climber wants to experience. Like being carried along by a river, being in the flow makes the work required feel weightless, effortless.

Frederick Buechner once said, "The place God calls you to is the place where your deep gladness and the world's deep hunger meet."[4] The calling to wade in, deeper and deeper still, until the flow of the current sweeps us into the river of purpose and imagination, is there for each of us to answer.

To be in the flow is to be completely immersed in an activity that we are practiced in, one we have worked to master but with just enough challenge to remain interesting, absorbing, and meaningful. We've often experienced the flow as a happy accident—one that seems to show up of its own accord when we've been fully engaged and productive.

It's a climber who knows the feel of the rocks beneath his feet and can scramble up a scree field with confidence. It's an artist who knows the way paint combines on a canvas to create a masterpiece. It's a builder who knows where to place each nail and moves through a construction site with ease. It's a shepherd who calls each sheep by name and knows just what each one needs.

The gentle sound of the stream has worked its charm on you. It's not a big change that you need but simply a shift in perspective: to see your work as having a higher purpose and meaning and to enjoy the mastery of skills you've attained along the way. You will allow those two energies to dance in each moment and enliven the work you've been given.

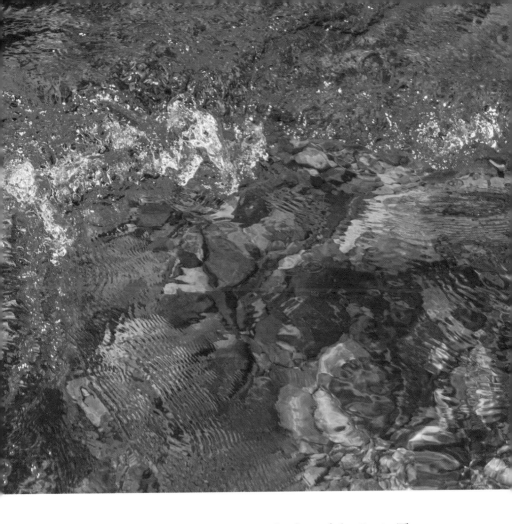

To answer this call is to step into the flow of the Spirit. The current will move you from one place to another as you remain immersed in the river of your purpose.

. . . that you may know the hope to which he has called you, the riches of his glorious inheritance.

EPHESIANS 1:18

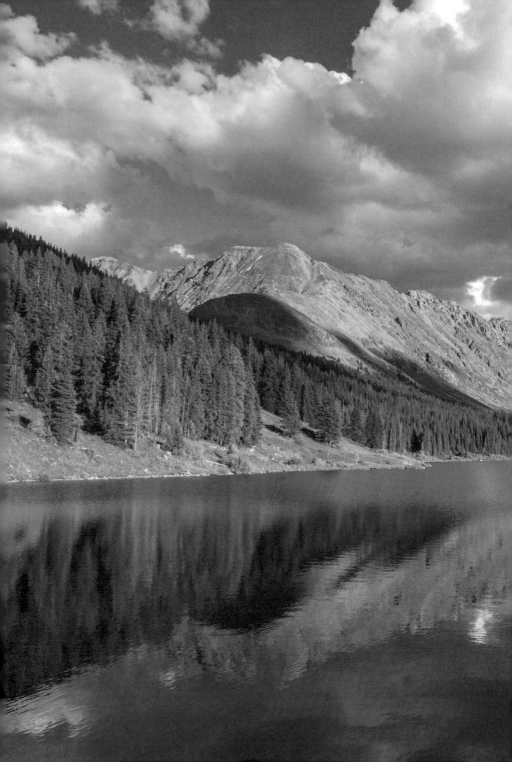

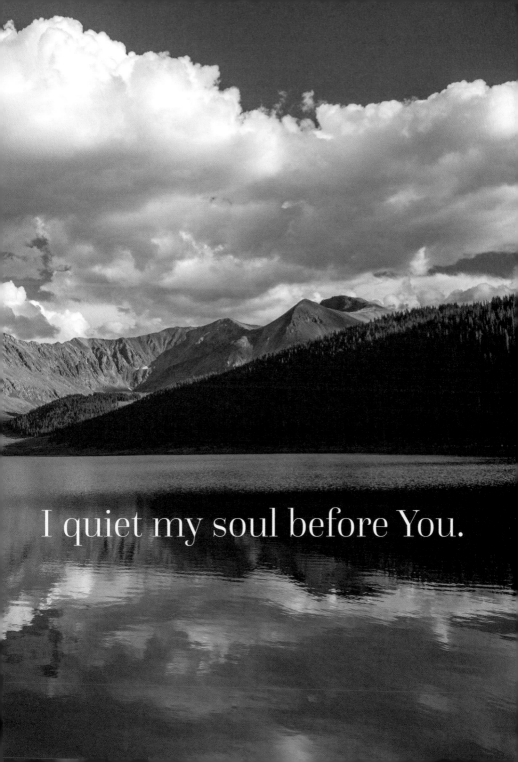

I quiet my soul before You.

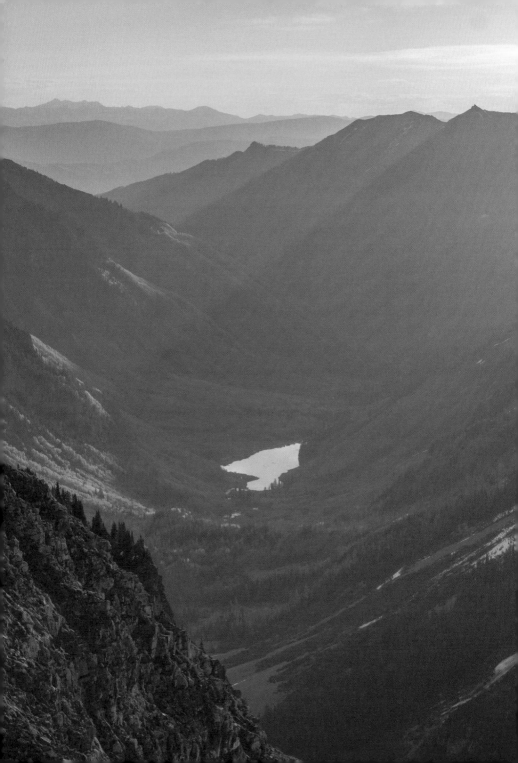

Examen

A bevy of clouds lingers above the ridgeline, waiting to be bathed in sunset hues as the day draws to a close. They've taken on an otherworldly air that shimmers with anticipation for the evening's grand finale. Tonight's sunset does not disappoint—it fills the sky, illuminating the waiting clouds with stunning colors that change moment by moment as the curtain falls on daylight and ushers in the night.

You stand in astonishment, dazzled by the display. Lost in the final moments, you've forgotten the details and worries of the day as you've watched the clouds glow salmon-pink, magenta, and purple. Like children, they play in the beams of light, creating shadow puppets in the sky for an indulgent world below.

Tonight's sunset has pulled your mind from the swirling activity of the day and filled you with gratitude. You are present to the beauty before you, attendant to delight and a sense of peace. The fading light invites an opportunity to reflect on a day that had, only moments ago, been rife with distraction. A looming decision, with far-reaching implications for your future, has dominated your waking thoughts and interrupted your sleep. And though you'd experienced the joy of a day in the outdoors, that worry over making a wrong choice edged out whatever happiness it brought.

But this sunset.

It stopped you in your tracks and, through its transcendent beauty, made you aware of God's presence. It is as if He put it here just for you, and you are grateful.

Thank You, God, for this.

Now as you go over the events of the day in your mind, gratitude seems to be taking you by the hand and walking with you. Under this divine Light, everything looks different. There are colors and nuances you didn't see before. You begin to hold each event and conversation up to the Light in a kind of wordless prayer.

You watch as the sun slips below the distant peaks, leaving the sky aglow with the last sparks of its rays. The clouds, now deep purple and gray, remind you of the jumbled anxiety that plagued you today, and it is from here that you ask for discernment. You see how you allowed the stress of your impending decision to invade your conversations and rob you of the peace that was available to you all along. You see how God is providing new opportunities to you and is helping you pinpoint where you can strengthen your relationships with others.

Without even knowing it, you have stumbled into a time-tested spiritual practice. Centuries ago, Saint Ignatius created a prayer practice called the Examen, which he encouraged all believers to make part of their day. The Examen remains a simple way to focus on the presence of God in your life and listen for direction.

- Become aware of God's presence.

- Review the day with gratitude.

- Pay attention to your emotions.

- Choose one feature of the day and pray from it.

- Look toward tomorrow.[5]

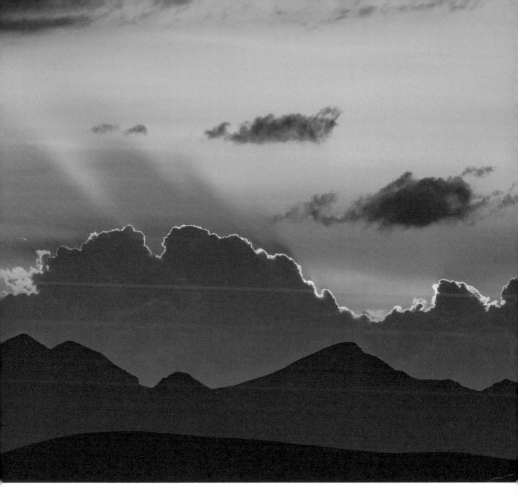

This sunset, in all its glory, helped you pause. It made you aware of God's presence—not just in the beauty of the moment but in the whole of your day.

Lord, help me be more aware of You in every moment of my day.

Devote yourselves to prayer with an
alert mind and a thankful heart.
COLOSSIANS 4:2 NLT

Failure

It's the final stretch along the ridge to the summit, and you're almost there.

You've been working toward this moment for weeks now: planning your route, buying the right gear, taking time off work, making arrangements with your friend to accomplish a big goal together. It's taken considerable effort and expense to make this happen, but it's finally about to pay off. You couldn't be happier.

The day started at dawn when you and your buddy set out to conquer this mountain. It's not a technical climb, but it's still one that challenges your abilities. Most of the route is fairly easy, Class 1, but there are a couple of sections that are dicey. Slippery shale and steep drop-offs along the way keep you on your toes, causing your heart rate to accelerate and palms to sweat. It's just enough to provide you with some good stories around the campfire—once you get off the mountain.

With only a couple hundred yards to go, you halt momentarily as the dull headache you've been ignoring explodes into a rage. Head pounding, heart racing, you stagger to a nearby boulder and reach for your water bottle.

"You okay?" your friend calls from up ahead.

Head too heavy to lift, you raise your index finger to indicate you need a minute to rest before continuing.

Returning to check on you, he assesses the situation quickly and informs you that you have altitude sickness. "We've got to get you back down the mountain," he says quietly.

At first you refuse to accept it. You can *see* the summit from where you are.

"I know I can do it," you insist, not realizing that you are experiencing "summit fever," a mental trap that causes climbers to make poor, often disastrous, decisions in order to reach the top.

You've worked too hard to give up. You are letting your friend down. You can't stop now.

Your friend gently shakes his head. "We'll get there next time," he says. "Remember, a successful climb is not one that reaches the summit, but one in which everyone gets off the mountain safely."

You know he's right, yet you still feel you've failed.

Failure, especially when it affects other people, is hard to make peace with. Sometimes we fail because of bad decision-making, and other times things happen that are outside our control. No matter the cause, regret over the past can haunt us unless we find a way to move past it.

> Regret over the past can haunt us unless we find a way to move past it.

Psalm 143:8 reminds us, "Let the morning bring me word of your unfailing love, for I have put my trust in you. Show me the way I should go, for to you I entrust my life."

When we fall short, when we are disappointed with ourselves, we can still trust in the One whose love never fails. He is always present to restore and rebuild, to lead and guide us into a pathway of grace.

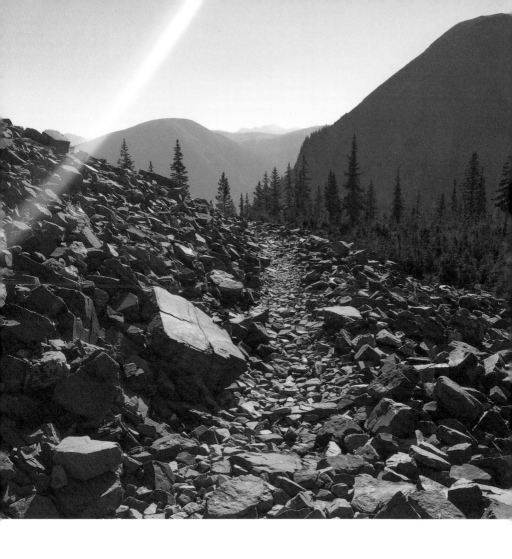

My grace is all you need.
My power works best in weakness.

2 CORINTHIANS 12:9 NLT

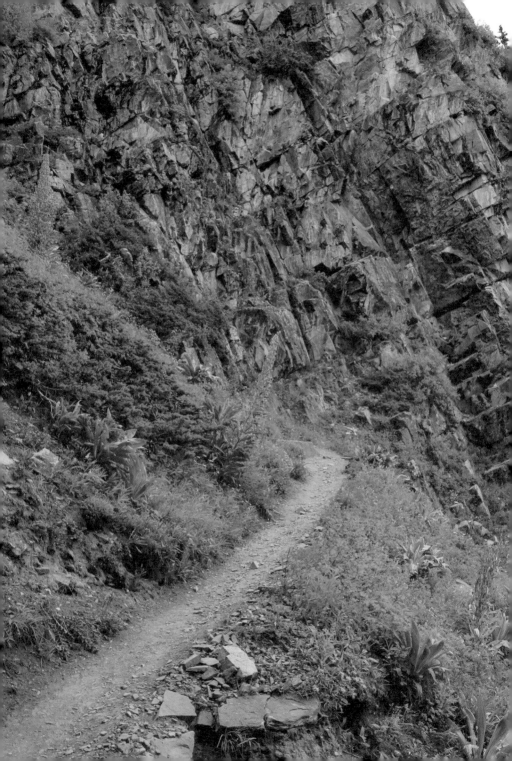

Resilience

Your mountain tests your mettle.

Well, it's not exactly an *actual* mountain, but it's your metaphor for the personal mission you've embarked on. It feels like the perfect analogy because, just like a real mountain, it requires more from you than you ever imagined. Today you are in the Rocky Mountains, and as you look at the formidable peaks in the distance, your heart swells with determination to reach your goals.

You knew it would be hard to reach the top, but this endeavor challenges you like nothing else. It is grueling at times: rocky ledges, slippery footpaths, unforgiving weather. You've made mistakes along the way, misjudged how far the destination is, and didn't prepare nearly enough for the resistance you'd encounter.

Friends don't understand your call to this mountain. "How about this other one over here? This one's easier, more suited to you," they say.

They mean well.

But this is the mountain that has your name on it, and you cannot let it go. It's your calling.

The *decision* to climb was the easy part. It was a task that needed doing, and you knew that God had been preparing you for it all along. The challenge, you find, is to *keep* climbing and keep going when everything in you wants to quit.

Somehow, you must grab ahold of your resilience.

The resilience you seek has taken residence in your bones. Forged in the fire of testing, you've discovered through the difficult

experiences of your past a strength you didn't know you had. In trials you thought might break you, you've found a resolve to keep going, to keep believing, to keep trusting that your calling is divine.

You bring to mind Joshua 1:9: "Have I not commanded you? Be strong and courageous. Do not be frightened, and do not be dismayed, for the LORD your God is with you wherever you go" (ESV).

And, goodness, the views are worth it. You've already glimpsed what you've only dreamed of, and you're not even to the top. Your vision for what is possible is expanding each day as you put one foot in front of the other and continue to climb.

That hard-won resilience rests in the power of a God whose presence goes before you. This mountain has shown you that whatever hardship you face, whatever battles you must fight, in Christ you have what it takes to keep pressing forward.

The Lord is with you wherever you go.

He gives strength to the weary and
increases the power of the weak.
ISAIAH 40:29

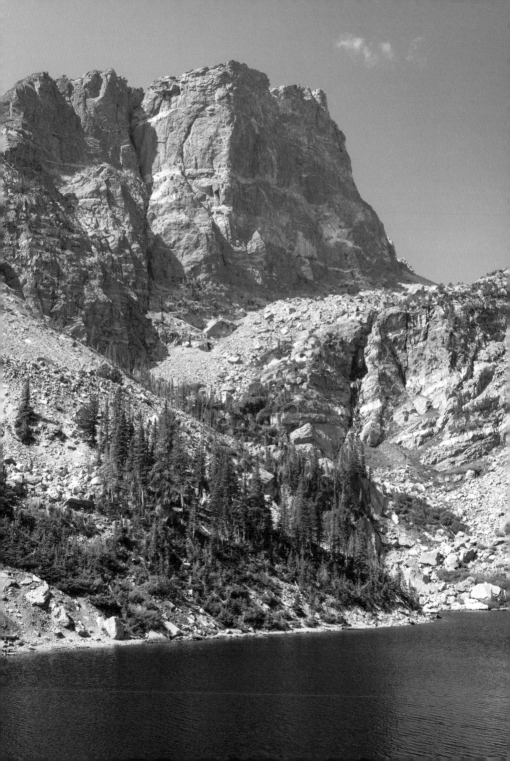

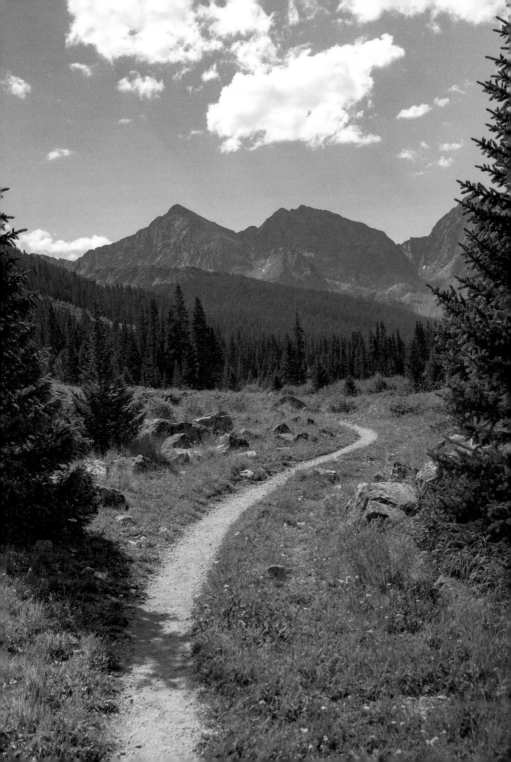

Pathways

Everybody needs beauty as well as bread,
places to play in and pray in, where
nature may heal and give strength
to body and soul.

JOHN MUIR

Today you are definitely not looking for a rugged adventure, just a place to unwind and clear your mind. In your heart, you are hoping for some clarity as you seek direction from the Lord, and the best place for you to hear His voice always seems to be outside in His creation. So you set out to find a good walking trail—not too far off the beaten path, not too difficult, but one where you can set a leisurely pace and simply *be* in nature. A paved pathway might even be nice.

You often come to the mountains to find clarity and direction. Though you make spreadsheets, talk with wise friends, weigh the pros and cons, and look at your options from all directions, there is nothing like simply allowing everything to settle while you walk on outdoor trails. You listen to the sound of your own footsteps and fill your lungs with fresh air.

Step.

Breathe.

Listen.

Observe.

Repeat.

The Latin phrase *Solvitur ambulando*, meaning "It is solved by

walking," comes to mind. Far from your spreadsheets and plus-and-minus columns, you relinquish the need to have a tidy solution today. Instead, you choose to spend your walk noticing—unhurried and deliberate.

You walk under the shade of a community of trees, each member helping the others flourish through underground root systems and micro-emissions that balance the forest. The fiddle ferns unfurl their fronds to catch the filtered sunlight on the forest floor, while delicate mushrooms poke through moist earth at the ferns' feet in another community of life.

Birds dart in and out of the branches, collecting seeds, searching for worms, filling the air with song. Chipmunks scamper about, then freeze—motionless—as they size you up. You encounter a charming stream that babbles under a footbridge, delighting you with its carefree dance through the woodland. Ahead, distant peaks seem to anchor the whole landscape with their immovable presence.

Rather than trying to untangle your problems as you walk, you engage your mind with the amazing world around you—the untamed spaces that you are privileged to walk through. Brown wooden signposts point you toward another trailhead or scenic overlook. If only the pathways in the rest of life were so clearly marked.

That's when it hits you: Following the Lord's leading is often less about what seems right on paper and more about watching for the signposts He gives us along the way. There are indeed arrows pointing us in the right direction—namely, the peace that comes when we follow His lead. Turning off the noise of other people's opinions, the

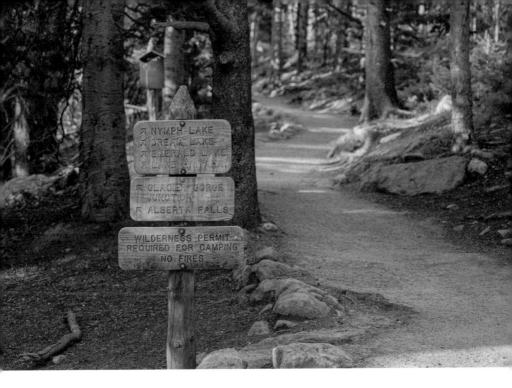

fear of missing His will, and the desire to know certain outcomes and tuning in to the quiet strength of His presence provides us with what we need to move forward.

We step. We breathe. We listen. We observe. We repeat.

Each step is an act of faith. We don't have to know exactly what lies at the end of the trail. We only need to trust that each step is ordered by the Lord. Just as the park service uses recognizable signage to indicate correct paths, the Holy Spirit provides recognizable peace to confirm we are on the right trail.

I will guide you along the best pathway for your life.
I will advise you and watch over you.
PSALM 32:8 NLT

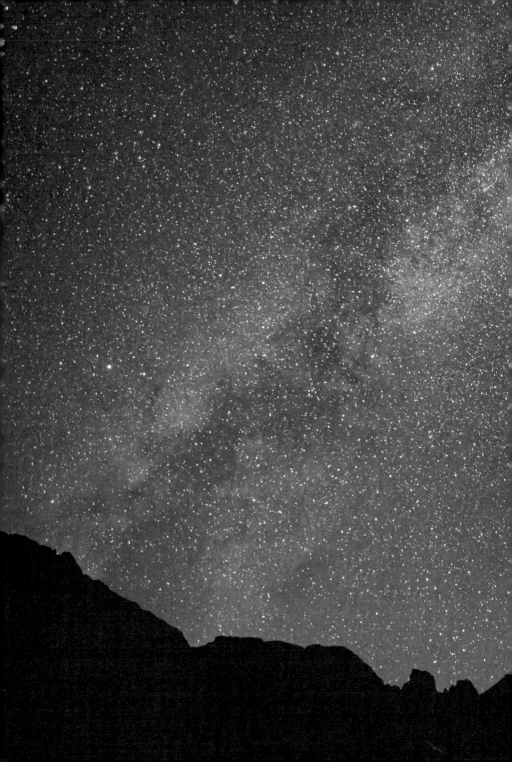

I am in awe of You.

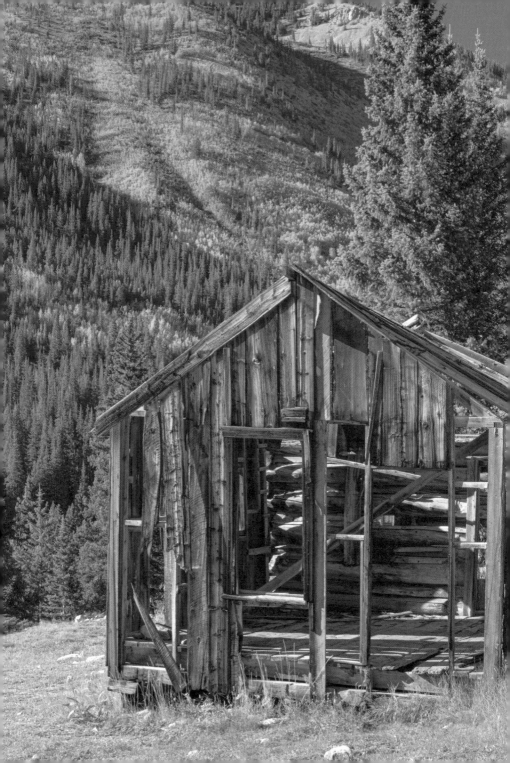

Abandoned

The rough-hewn logs bear the marks of axes that notched their ends into pieces that could be joined together to build a small cabin. Barely big enough for a bed, a cookstove, a table, and a chair, the house still stands—although its roof and floor rotted away long ago. All that remains is the structure, its bones refusing to give in to the elements that try to reclaim it.

To stumble across an old settler's cabin in these mountains brings about a sudden melancholy that surprises you with its depth. It is a feeling of bumping into the past and not knowing whether to tip your hat and keep going or loosen your backpack and sit.

You choose the latter.

A bit of old cloth flutters at the window—perhaps a slip of ribbon to tie a curtain back? Seeing it makes you wonder about the people who once arrived with such hope and optimism, enough to hang a floral curtain on a rough log cabin. Did they succeed in building the life they dreamed of? Or did the dark winters and short summers, the inhospitable ravines and treacherous passes wear away at their hopes? Did crops fail, or a gold vein run dry, or a loved one die . . . dashing all their dreams until they simply walked away?

Abandoned structures like this often bring a sense of something lost, a sadness for a time gone by, but perhaps they could be symbols of something else too. This tiny log cabin was never meant to be a "forever home." It was always intended to be temporary—a shelter from the elements—until something better could be built. It kept a miner

warm during the cold months until he hit that mother lode of gold. It sheltered a young family until supplies could arrive for a bigger home in town. Maybe it kept a settler safe as he waited to send for loved ones back east. Whatever the reason, this cabin served its purpose for its occupants on their way to new dreams.

You can imagine how each occupant looked back over their shoulder, whispering a prayer of thanks as they left the simple structure that once gave them shelter. No doubt some gave thanks that they would never have to see it again. Others gave thanks for the place that allowed them to get back on their feet, to dream again, to find their way.

Our past holds its own abandoned structures, old bones that remind us of dreams we've given up as our hopes slipped away. We look back with a mixture of sadness and nostalgia for a simpler time filled with optimism and hard work for something we once believed in: a

> Our past holds its own abandoned structures.

cause or a goal or a dream. It's hard to let go, to move on. Perhaps we can now begin to understand that those places were never meant to be our "forever homes." They were a temporary shelter on the way to something bigger, something better, something lasting—just as the Old Testament law was a temporary structure designed for a specific purpose. The coming of Jesus as our mediator made the old way obsolete. The "old" made way for eternal grace and truth.

Galatians 3:19 says, "The law was designed to last only until the coming of the child who was promised" (NLT).

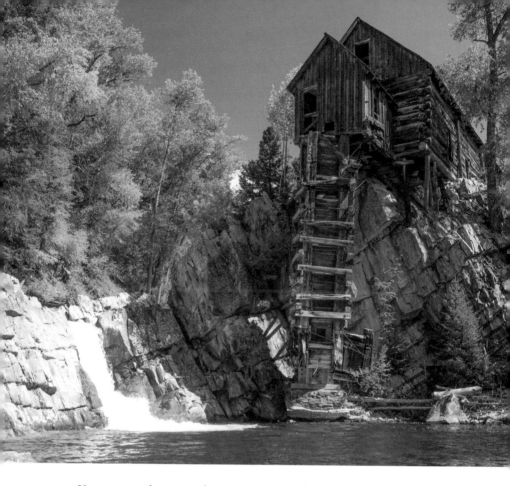

You turn to leave, picking up your pack and putting it on your back in one practiced move. Your destination lies ahead, and this spot has given you a moment to reflect on the grace that has always been present in your life. Glancing over your shoulder, you give thanks for the experiences along the way that have provided what you needed for the next leg of your journey.

Grace and truth came through Jesus Christ.

JOHN 1:17

Immanence

Morning arrives soft as dewdrops.

Shrouded in gauzy gowns of mist that seem to float effortlessly about them, young pines line your path to greet the day. At their feet, tender grasses and newborn wildflowers gulp the tiny airborne droplets in the stillness of the hour. If you listen hard, you can almost hear the moisture travel the length of stems to unfurl translucent petals and pale green leaves.

Day has begun.

The ground beneath your feet has a spongy feel, and each step brings a waft of humus—the smell of last autumn's leaves decaying into the earth to become the soft bed of new life. A troop of white mushrooms poke their caps through the dirt and tip them toward the sun as if eager to say thanks.

You've planned a day filled with awe-inspiring vistas and grand peaks to photograph, but it's the mountain harebells that have caught your attention—bell-shaped purple blooms that are still nodding their sleepy heads in the morning light. Paper-thin, their delicate petals are glazed with dew, catching the light and seeming to glow from within like Japanese lanterns.

What a treat. You stop in your tracks to gaze at them. You are compelled to take a closer look, so you bend a knee into the damp earth to inspect them, the five petals gently curving out, barely concealing the yellow stamens like bell cappers inside. A puff of wind animates the blooms in all directions, and you almost imagine them as a bell choir ringing:

> This is my Father's world,
> and to my listening ears
> all nature sings and 'round me rings
> the music of the spheres.[6]

Perfectly at home in mountain meadows as well as wind-swept rocky mountainsides, the harebell's dainty appearance belies its sturdy backbone and tenacious roots. It's audacious generosity—to bloom in these wild places with no thought or care to be seen and admired but to radiate beauty for its own sake—strikes you as inhabiting a divine sense of being.

How can something so small feel like such a gift in the immense grandeur of a mountain setting?

John Muir, the nineteenth-century naturalist, once said, "Oh, these vast, calm, measureless mountain days . . . ! Days in whose light every- thing seems equally divine, opening a thousand windows to show us God."[7] He was as enchanted by dainty flowers and lichen as he was by the awesome peaks and valleys he explored in the untamed wilder- ness places. It was God's immanence—His presence in creation—that moved him to pen those words, and it's that immanence that moves us still. We are caught in the sacredness of a world that oozes with His mys- terious presence, if only we turn aside to see it, touch it, experience it.

In the ancient language of flowers, the bluebell family is a sym- bol of humility, constancy, gratitude, and everlasting love.[8] How fitting

then that God's all-encompassing love and constant presence is perfectly expressed in these tiny harebells today. The joy of their unexpected appearance, enough to stop you in your tracks, is a gentle reminder of your heavenly Father's care and delight in you. They are quiet whispers of His immanence: God with us, Immanuel.

The harebells chime forth His presence in this space, just for you.

From him and through him and for him are all things.
To him be the glory forever! Amen.

ROMANS 11:36

Shelter

The morning hike brings photo opportunities of stunning vistas that fill the memory space on your phone—and in your soul—with scenes of grandeur. Every turn in the trail reveals views fit for a postcard, making you laugh with near-disbelief and delight. *How can everything be this beautiful?* It's as if you're seeing a series of elaborate theater sets, designed for maximum admiration—almost too perfect to be randomly placed in the wild and happened upon by human explorers.

And yet here it is. Nature's splendor is on display, and you sense you are a bit player on this stage as the scenes unfold before you.

A glance at your watch reveals that the day is slipping away. In your eagerness to see everything this hike has to offer, you've lost track of time.

You remember how important it is to descend from the higher elevations and find shelter from the afternoon storms, and now with a sense of urgency you turn to retrace your steps down the mountain.

Almost on cue, the air around you begins to feel heavy as its molecules fill with moisture.

The sky, which had been decorated with a few puffy clouds floating over distant peaks, is suddenly full of glowering dark masses that have been summoned from the wings and now take center stage.

Distant thunder, a long rolling rumble that echoes across the canyons and back again, causes your pace to quicken. The sky lets loose just as you reach the door of your cabin, and you are drenched before you can get inside. Ice-cold drops the size of quarters pelt the thirsty ground, splashing off rocks and dripping from branches in a curtain of rain.

Grateful for the shelter, you peel off wet layers and shiver as you rub your chilled skin briskly with a thick towel. The rain on the rooftop sounds like a troupe of dancers on a stage in constant movement—leaping, landing, spinning, cascading, falling. It feels good to be safe and warm inside this little refuge in the woods.

As you wait for the storm to pass, you can't help but think of the other storms you've weathered: the loss of a job, being let down by friends, the unexpected medical diagnosis, a difficult relationship with someone you love. Some of them arrived without notice, but many could have been anticipated—if you'd been paying attention. You know that storms are an inevitable part of life, but sometimes you've forgotten. Your mind considers the storm you're facing in your life right now, how it caught you by surprise in its intensity even though deep down you somehow knew it was coming. The air had felt heavy for quite a while.

Thank God for shelter.

Storms are an inevitable part of life.

On mountainsides and in everyday life, it's important to know where the safest place to take shelter is. The Psalms are filled with references to God as our place of refuge, including this one: "Whoever dwells in the shelter of the Most High will rest in the shadow of the Almighty. I will say of the LORD, 'He is my refuge and my fortress, my God, in whom I trust'" (Psalm 91:1-2).

The raindrops on the rooftop begin to slow, and a shaft of light

appears where sunlight pokes through a break in the clouds. You remember that we have not been promised a life that's free of troubles or skies void of storms, but we are given shelter in God's presence when those things happen. In Him there is protection, strength, and comfort.

You are my hiding place; you will protect me from trouble and surround me with songs of deliverance.

PSALM 32:7 NIV

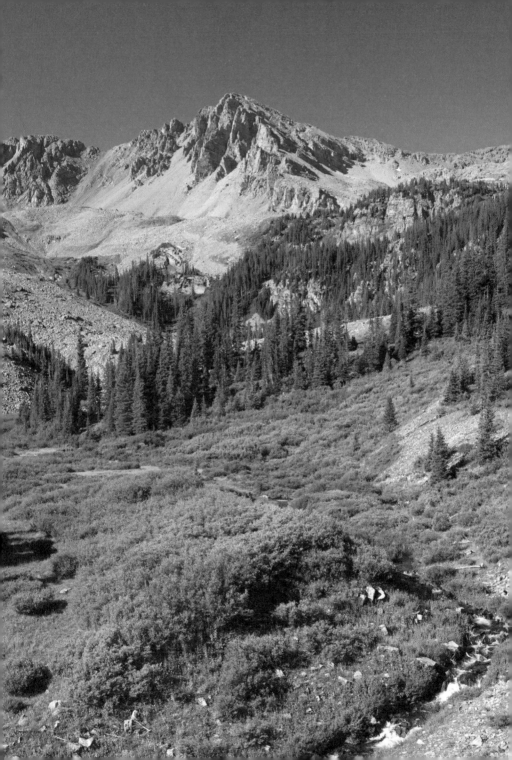

Spacious

The valley is off the beaten path—namely, four miles past the end of the "maintained" dirt roads and up a potholed, bouldered pathway accessible only to four-wheel drive vehicles and hikers. It is tempting to turn back, except for the tantalizing glimpses of distant peaks and glorious forests, lit by the morning sun as you bump and bounce your way closer to your destination.

With one final jolt and turn, you leave the forest and arrive at a wide-open space. Here, the valley floor is alive with native grasses, shrubs, sages, and wildflowers. A small river meanders through, breaking into delicate rivulets and eddies, and then braids itself together, unhurried and content in its journey.

Trees—aspen, spruce, and pine—embroider the sides of the surrounding mountains, softening the rocky edges with their leaves and limbs.

But the stars of the show are the peaks at the far ends of the valley. Like bookends, they make a majestic statement. Rugged faces catch the light through the atmospheric haze and create a stunning backdrop to the verdant valley between them.

You are gobsmacked by the beauty.

Turning off the engine, you step into the meadow, and without thought you open your arms wide, palms forward. Instinctively your chest is expanded, face raised. The cool breeze lifts your jacket away from your body, and you feel you are as wide as the valley.

Open.

Spacious.

Vast.

Free.

Your soul mirrors the grandeur of nature, the shalom of your Creator.

> Your unfailing love, O LORD, is as vast as the heavens;
>> your faithfulness reaches beyond the clouds.
> Your righteousness is like the mighty mountains,
>> your justice like the ocean depths.
> You care for people and animals alike, O LORD.
>> How precious is your unfailing love, O God!
> All humanity finds shelter
>> in the shadow of your wings.
> You feed them from the abundance of
>>> your own house,
>>> letting them drink from your river of delights.
> For you are the fountain of life,
>> the light by which we see (Psalm 36:5-9 NLT).

Caught up in this moment of openness, you are alive to a God who fills all things with Himself, who has room for compassion for all humanity and all creatures, and who gives light and life to the world.

He is a spacious God, says your heart.

How much of our lives are spent with arms crossed, brow furrowed, body collapsed in on itself? What makes us close our hearts to

living fully, to seeing the world and its inhabitants with compassion, and to believing in a God who is bigger than we can imagine? So often we slouch along, our bodies emblematic of minds and hearts crippled by smallness, by closure. The act of stepping into a spacious place with our bodies expansive and wide becomes a gate through which our inner selves can begin to unfold like butterflies from cocoons. The physical movement informs our minds and unfurls our spirits to worship, to freedom, and to wonder.

Open, we can at last begin to receive the divine love that overflows from the vast riches of our Father's heart, poured into all of creation.

Your unfailing love, O LORD, is as vast as the heavens.

PSALM 36:5 NLT

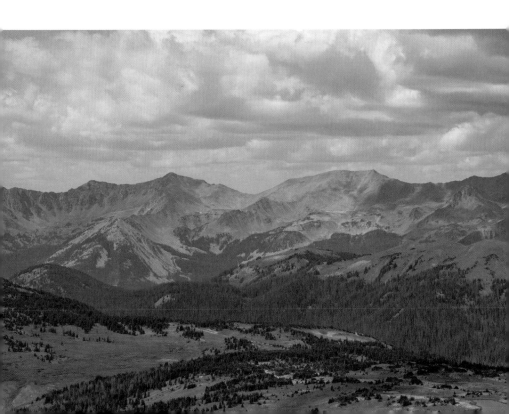

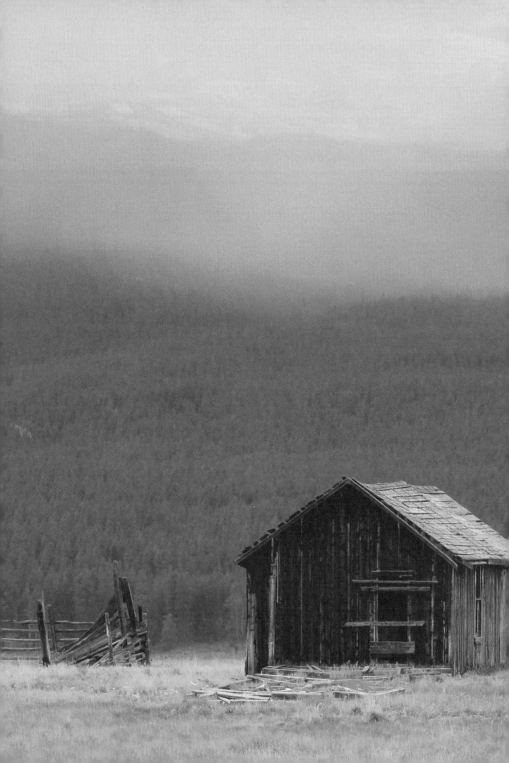

You watch over the
seasons of my life.

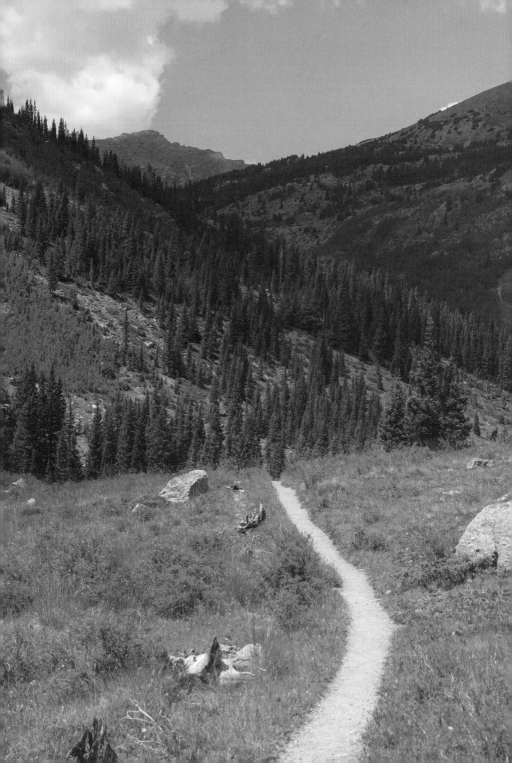

Essentials

The sky above is a deep azure blue, decorated with ever-changing white clouds that seem to revel in the winds aloft. They dance and shape-shift, delighting in their shadows, which move like partners across the valley dance floor. The smell of pine, cottonwoods, and summer grasses is nearly intoxicating in the cool alpine air that swirls along with the dancing clouds. Between the warmth of the sun and the chill of the breeze, you're not quite sure whether to keep your jacket on or strip down to your T-shirt. Layers, the experts say, are the key to staying comfortable when you explore the landscape.

As you emerge from the forest into the open meadow, the sun chases off the frolicking clouds, and the choice is suddenly clear: time to remove a layer. You unfasten your day pack and set it down on a rock that's baking like a fresh bun in the sun. Unzip the jacket and stuff it into the pack. Pause and consider. Take the sweater off while you're at it?

Peeling off unnecessary layers in the warmth of the sunshine is a reminder of the layers that need peeling in your interior landscape. Where did your joy go? When did your simple faith get buried? Your soul has felt suffocated under the weight of religious wrappings that once seemed helpful. In the busyness of life, you haven't had time to think about the extra coats that have been binding your faith—layer by layer—until you could barely move.

Here in the penetrating warmth of God's love, it suddenly seems so obvious: It's time to strip off the layers until you are free.

Unbuckle, unzip, lay it down.

Experience the dancing shadows on bare skin.

Sense God's delight in your unfettered soul.

Let go of the layers of your faith that are tangled up in require-
ments, performance, achievements, and people-pleasing. Bare essen-
tials only.

The words of the Nicene Creed provide our base layer:

> *We believe in one God, the Father, the Almighty, maker
> of heaven and earth, of all that is, seen and unseen.*
>
> *We believe in one Lord, Jesus Christ, the only
> Son of God, eternally begotten of the Father, God from
> God, Light from Light, true God from true God, begot-
> ten, not made, of one being with the Father. Through
> him all things were made. For us and for our salvation
> he came down from heaven: by the power of the Holy
> Spirit he became incarnate from the Virgin Mary, and
> was made man. For our sake he was crucified under
> Pontius Pilate; he suffered death and was buried. On
> the third day he rose again in accordance with the
> Scriptures; he ascended into heaven and is seated at
> the right hand of the Father. He will come again in
> glory to judge the living and the dead, and his kingdom
> will have no end.*
>
> *We believe in the Holy Spirit, the Lord, the giver
> of life, who proceeds from the Father and the Son.*

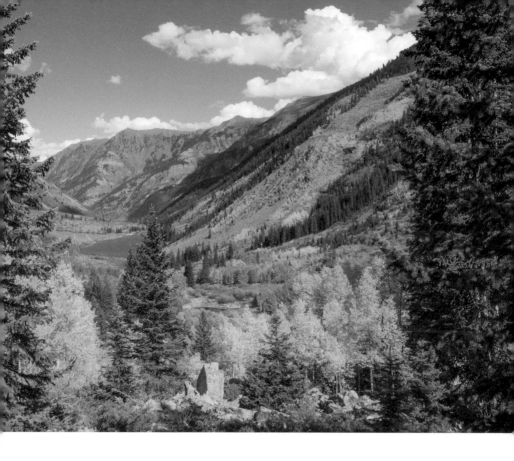

With the Father and the Son he is worshiped and glorified. He has spoken through the Prophets.

We believe in one holy catholic and apostolic Church. We acknowledge one baptism for the forgiveness of sins. We look for the resurrection of the dead, and the life of the world to come.

Amen.[9]

Now this is eternal life: that they know you, the only true God, and Jesus Christ, whom you have sent.

JOHN 17:3

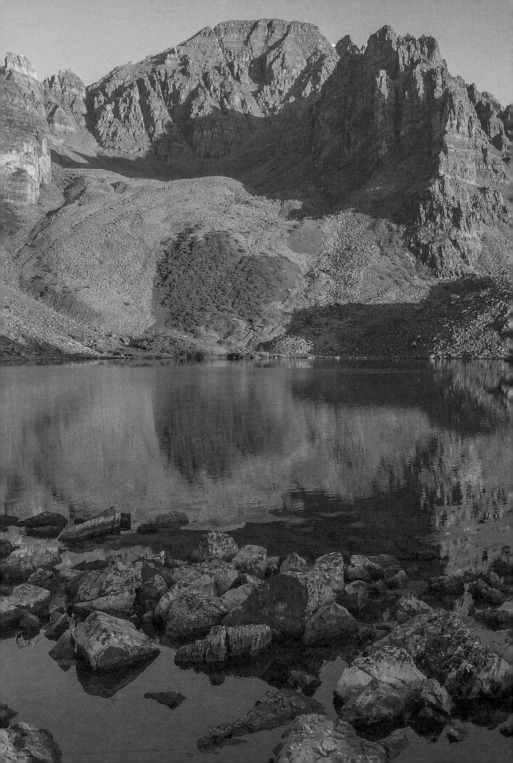

Reflections

The lake rests in a small alpine valley between granite peaks. It takes a half day of serious hiking to reach its remote location, which is marked on the topographical map in your pack and listed as a "moderate hike" in the trail guidebook back at the lodge. In hindsight, before you left, you might have paid closer attention to the topographic lines that indicate elevation gain, with one particular scramble over shaley rocks making you question if it would be worth the work to get there.

It is.

As you emerge from the forest and head toward the clearing, you see glimpses of water beyond the tree trunks, and your pace quickens. Hard ground becomes spongy beneath your feet—softening the sound of your footsteps as you turn one last corner to take in the full view.

The water is so still it mirrors the surrounding trees and mountains and a sky so blue that a gasp escapes your lips. Its surface is a perfect reflection of the alpine scene, with scarcely a ripple of movement to hint which side of the view is up.

As white puffs of clouds drift slowly across the sky, their counterparts slide across the water. It is all you can do to tear your eyes from the mesmerizing scene to find a flat, dry rock to serve as a lunch table.

Sitting here with a sandwich and flask of cool water, you marvel at the feeling of grace that warms your heart. How is it that this spot isn't filled with day packers like yourself today? With its unmatched beauty, you would think there would be scores of people here to take it in. You wonder how many gems are just beyond what is considered

comfortable for the casual hiker. It takes effort to reach a place of reflection like this one.

As you look around the small body of water, you juxtapose this lake's tranquil existence in the present time against how it was brought forth: by the violent glacial movements that gouged deep scars into the rock in eons past. The unfathomable power of shifting continents and retreating ice fields over time created new environments for forests to be born and wildlife to flourish. It made space for the beauty of this majestic lake.

You cannot help but reflect on your own pathways to grace. Thinking back over your life, you see how those moments of deepest hurt made tender places for God to work. You see now how a thread of love carried you over dark abysses and dangerous canyons to bring you to a place of abundance and joy. None of it happens in huge miraculous moments— each change is nearly imperceptible—yet slowly your life is becoming a reservoir of the kind of grace that is a reflection of God's glory.

All of us, with unveiled faces, seeing the glory of the Lord
as though reflected in a mirror, are being transformed
into the same image from one degree of glory to
another; for this comes from the Lord, the Spirit.

2 CORINTHIANS 3:18 NRSV

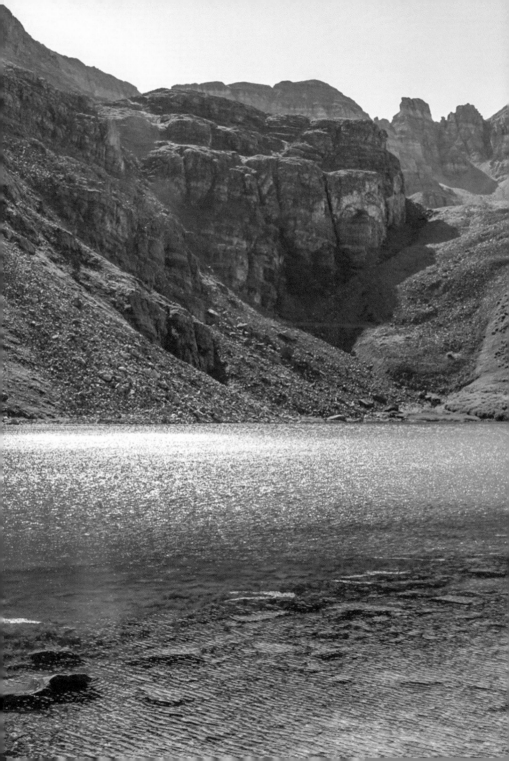

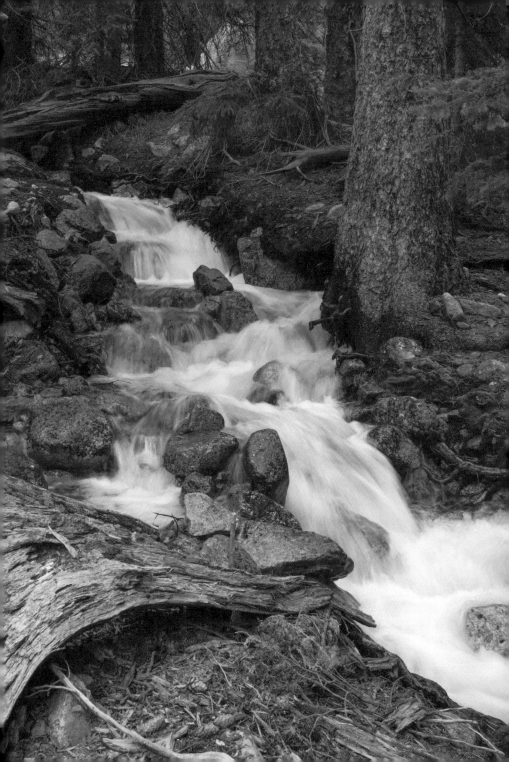

Burdens

Life weighs heavily sometimes.

Lately, it's felt like you've been hauling around a load of rocks on your back. The bulging rucksack seems to sit low on your shoulders, making you slouch forward as you walk, and you've found yourself unconsciously sighing deeply in odd moments.

"Is everything okay?" a friend asks with concern. "What's that sigh about?"

"What's that? I'm sorry. I didn't realize." You shrug, hoping to drop the subject.

It's hard to put a finger on it, but the weight feels like a kind of grief, and you're not sure why that is. It's what has brought you to this mountain waterfall: to sit and to decompress, to journal, to try to figure things out.

You find a grassy area near the water to spread out your jacket and lean against a tree. A fine mist lands on your face every now and then, and you know your journal pages will be damp in short order. But the view of the waterfall is perfect here, and what's a little moisture, anyway? Your notebook is open, pen uncapped.

A pair of mountain chickadees has found a small pool to splash in: shallow water lapping against pebbles, clear as glass. You can't help but be charmed by their antics.

Your journal pages are still blank. *How long have I sat here?* The birds have by now long flitted away, and you are simply staring, as if mesmerized by the water as it steps and pirouettes down the rocks.

A master choreographer could not design a more graceful dance.

Boulders, all different sizes and perfectly placed at random, create a graceful cascade of water by anchoring the choreography that leaps and splashes with carefree abandon. To your ears, the gurgling bubbles in the small eddies sound like laughter, the rushing water like the swish of flamenco dresses, and the spray like constant applause. *Brava! Brava!* Branches above sway to the music as the mosses soak it all in—lost in the movement around them, oblivious to all but the beat of the droplets on wet rocks.

You sense the tightness loosening in your chest when you see, as if for the first time, the beauty of those boulders. Without them there would be no dance of water, no rhythm of droplets, no splashing pools for birds. Rather than act as impediments, the rocks give form and structure to the life-giving cascade.

The rocks give form and structure
to the life-giving cascade.

In your mind's eye, you imagine what would happen if you unpacked the rocks you've been carrying around and threw them into the stream. The burden of responsibilities, the weight of unanswered prayers, the load of inexplicable sadness. Would they stop the water? Or would the flow of the waterfall find a way to caress them, move through them, and leap over them in a ballet designed by a Master Choreographer?

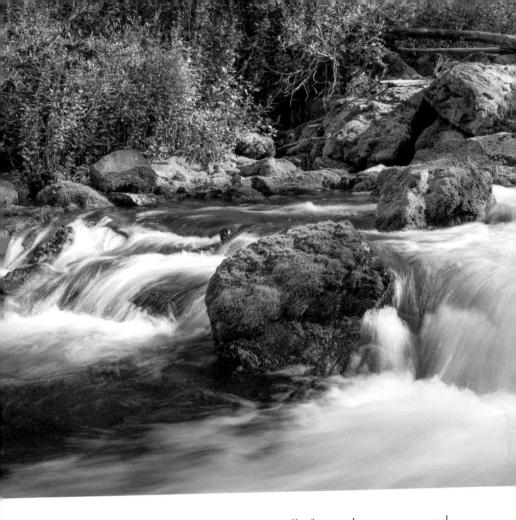

Matthew 11:28 says, "Come to me, all of you who are weary and carry heavy burdens, and I will give you rest" (NLT).

Perhaps the loads we carry are meant to be left in the river of life, creating pathways for the Spirit to refresh, renew, and reclaim in a dance of unstoppable grace.

Cast your cares on the LORD and he will sustain you.

PSALM 55:22

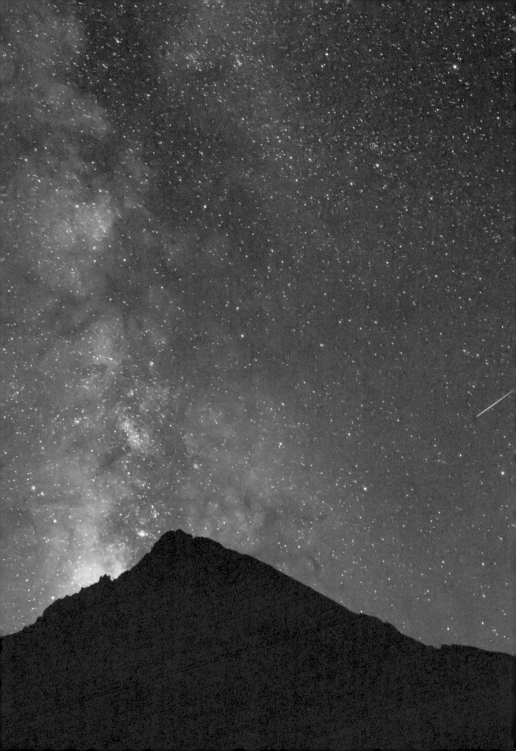

Wonder

Your fingertips tingle in the cold. Even in midsummer, nighttime in the mountains means "remember to bring gloves." Reaching for a pair, you realize it's also the anticipation of the celestial show that is about to start that's causing you to rub your hands together.

The forecast calls for clear skies with no moon, conditions that are just right for stargazing tonight. Up here, away from city lights, the stars are magnificent. You just have to stay up late enough to get the full view of the Milky Way as it traverses the sky.

With a thermos of coffee, a sleeping bag, and a few extra blankets, you make your way to a spot away from tree branches. There, you'll have an unobstructed view of this spiral galaxy, planet Earth's home in the universe. Of course, you've seen photos of what the Milky Way looks like, but nothing fully prepares you for the wonder you are about to encounter.

Finally, evening fades into the night, and the stars begin to turn the volume up on their glory. Rising in the southern sky, the Milky Way now takes center stage.

You are speechless at the sight.

What looks like illuminated clouds are really masses of stars so thick they give the milky illusion that the galaxy's name is derived from. Could this glorious celestial marvel be the "river of fire" flowing from the Ancient of Days (Daniel 7:10)? Your knowledgeable friend tries to give you facts about our galaxy—its immensity and scale—but your brain doesn't feel able to compute the information, so you fall

into silence. Your place in this vast world, already infinitely small, now within a galaxy that is only *one* of an estimated 200 billion galaxies, begs more questions than answers.

What does it all mean?

You can't help but wonder.

You feel a kinship with the psalmist David, who looked up at this same Milky Way thousands of years ago and asked:

> When I look at the night sky and see the work of your fingers—the moon and the stars you set in place—what are mere mortals that you should think about them, human beings that you should care for them? (Psalm 8:3-4 NLT).

Pulling your sleeping bag tight around your shoulders, you rest your head on the blanket beneath you and exhale. Above you, the work of God's fingers speaks the language of eternity and infinite creativity. The farthest stars are all within His reach, held together by a cosmic web of divine design—and yet . . . His Spirit resides within you and makes you alive to His presence.

He is mindful of you.

He is here.

He holds all things together.

In him all things hold together.

COLOSSIANS 1:17 NIV

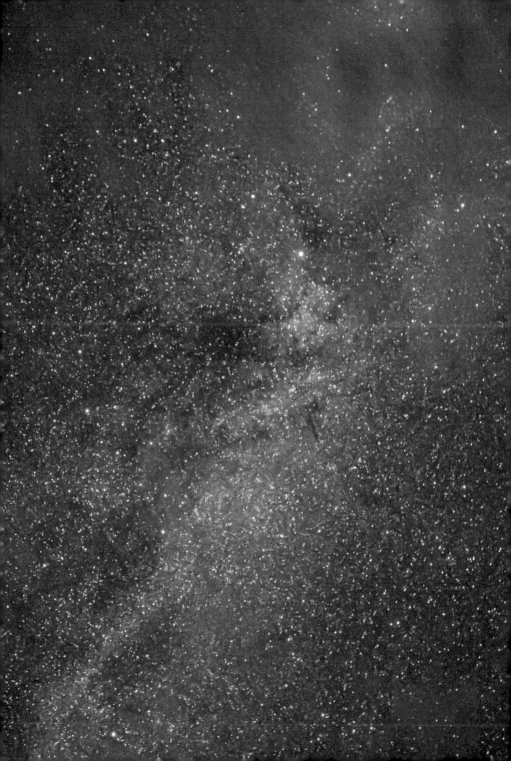

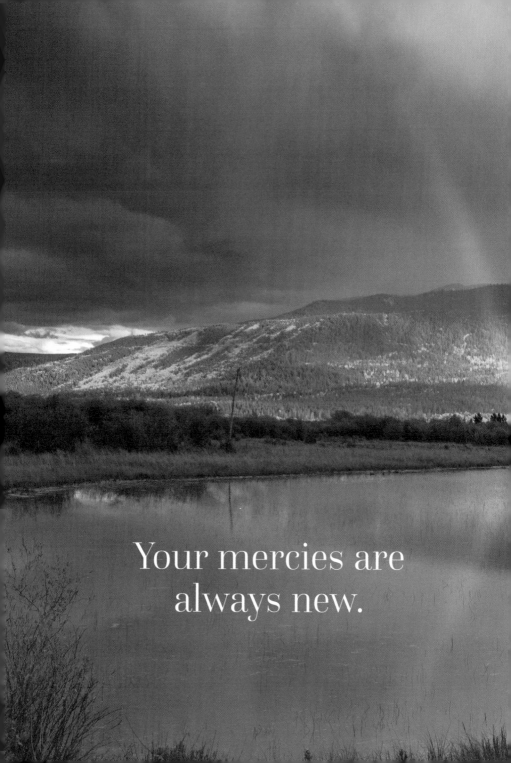

Your mercies are always new.

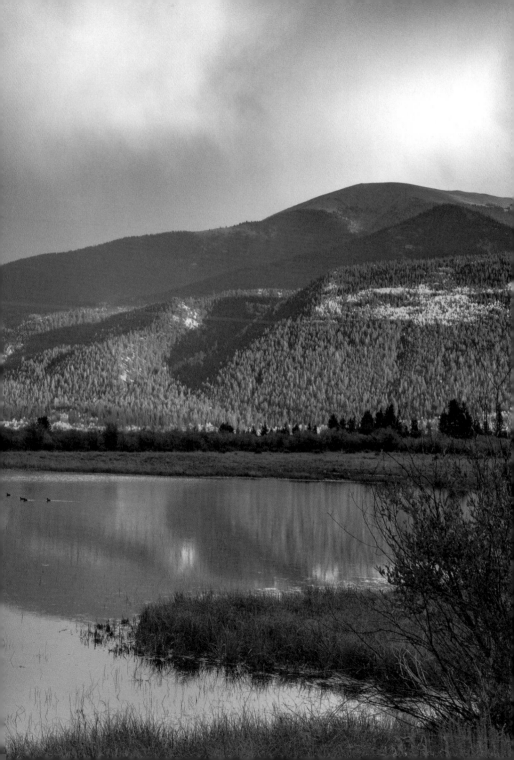

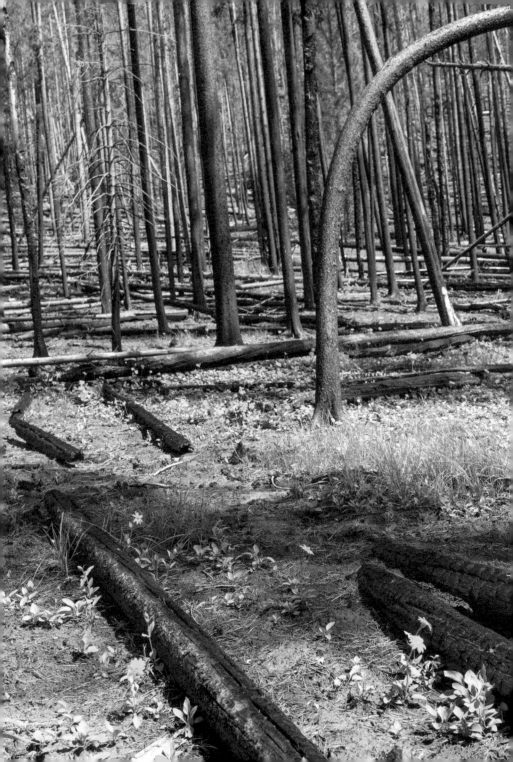

Healing

The charred remains of a forest ravaged by last year's wildfire is a shock to your eyes. Like a scene from a dystopian world, hillside after ashen hillside goes by as you drive—the burned tree skeletons leaning at macabre angles. *Oh, the loss!* The loss of these old-growth forests, of all the wildlife that flourished there—it's incomprehensible. You cannot imagine the fury of a fire so large it could leap over roads and create its own weather, sparking *new* fires in its path.

Nothing is left except the blackened ghost of what once was.

The melancholy lingers long after you leave the fire-ravaged area and return to the green, untouched landscapes. Seeing the stately virgin pines of the nearby forests, each surrounded by families of younger trees, feathery ferns, and colorful underbrush, only exacerbates the sense of incalculable ruin.

Wildfires are often caused by careless people who did not heed the "no fire" warnings issued by the forest service. They can also be caused by lightning strikes, made all the more devastating during droughts and changing climates. No matter how they start, you feel a sense of helpless anger, and you wish there was a way to make them all stop.

Your companion remarks that you are about to pass through an area that had burned several years ago, and you sigh. You're not sure if you can bear to see another dead mountainside. "Just wait until you see it," he says.

Rounding a corner, you are stunned at the sight before you. The charred stumps that populate the landscape are nearly obscured by

new trees. The young pines stand sprightly, their soft green limbs reaching toward the sun. Ferns dot the scarred floor, along with delicate grasses and pops of cheeky wildflowers.

A new forest is emerging from the ruins.

A tear of joy forms in the corner of your eye, and you cannot help but exclaim over the miracle. The whole mountainside is alive with growth.

Fires can bring about a rebirth—not a replacement of the old forest but a whole new ecosystem that will emerge from the ashes and flourish.

We have all experienced our own personal wildfires—the ravaging destruction that brings overwhelming loss and despair. In the face of the flames of cancer's fury, the dissolution of a marriage, the "restructuring" of a job, we stand helpless as the blazes seem to rage out of control. What was once a flourishing part of our life is now charred and lifeless. The indiscriminate nature of fire—how it burns one area

A new forest is emerging from the ruins.

and not another—leaves us with a sense of anger, a loss of control, a visceral despair. Despite our best efforts, we cannot make it stop.

Being witness to the birth of a new forest arising from the ashes is a reminder that no matter how devastating the fire, there *will* come a day when something will be reborn in your own life. In fact, upon reflection, you can already begin to see glimpses of new life, surprising you with their appearance in your charred landscape.

Hope begins to beat in your chest.

It's as if God knew you needed this reminder today. Out of the ashes, He makes all things new. No amount of ruin is ever final. He breathes life into what has been destroyed and creates a flourishing new world bursting with fresh growth.

Look, I am making everything new!
REVELATION 21:5 NLT

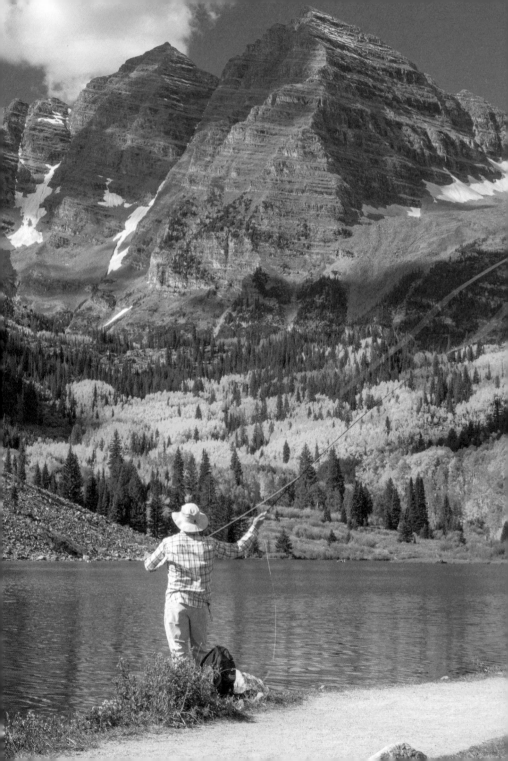

Familiarity

An older couple sits in folding chairs near the edge of the picturesque lake. They've brought a cooler filled with cold cut sandwiches, potato salad, chips, and cookies and are laying out a blanket for an afternoon of autumn enjoyment.

The man smiles as you approach the area for a good viewing spot. "Come on over," he says. "How ya doing today?"

"Doing great!" you respond. You motion to their spread in admiration. "Perfect day for a picnic."

"It certainly is." He turns to face the majestic peaks in the distance, still shrouded in morning mist. "Look at that view. It never gets old."

"Sounds like you've been here before," you say.

"Been coming here every autumn for thirty-five years!" He laughs. "We know these peaks by heart, and yet each year we see something new and wonderful. It's just like seeing them for the first time, every time."

You fall into companionable silence. This is only your second time here, and you almost didn't come because, well, you've seen it before. In mountain country, it's tempting to keep exploring new parks and trails in search of novel experiences, stickers for your tourist book, places to check off your list.

This chance conversation has made you rethink things.

To give yourself time and space to fully experience a place over and over again isn't something you've considered. Sure, you've returned a

couple of times to certain places, but you found yourself bored with the familiarity, restless to move on, impatient to see something different, something more exciting.

The couple next to you is chatting quietly, taking turns pointing out things and making observations. They haven't even touched their potato salad yet.

They are in the moment.

Unhurried.

Curious.

Joyful.

They are allowing the place to reveal its secrets and to charm them once again, in its own time.

It occurs to you just how often we discount the importance of what's familiar because we're always looking for something new.

Our eyes skip past passages in the Bible because we already know what's in them.

We hurry through prayer because it feels so repetitious.

We feel impatient in a worship service.

We feel bored with our faith.

We haven't appreciated the spectacular beauty right in front of us because there may be a more exciting view on the next mountain. Our need for "new and different" has edged out our ability to stop and savor.

The famous maroon ridges now seem to glow in the afternoon sun, the golden autumn aspens framing them in spectacular fashion.

The colors, *oh the colors*, are especially brilliant.
And now? You see everything as if for the first time.

Open my eyes to see the wonderful truths
in your instructions.

PSALM 119:18 NLT

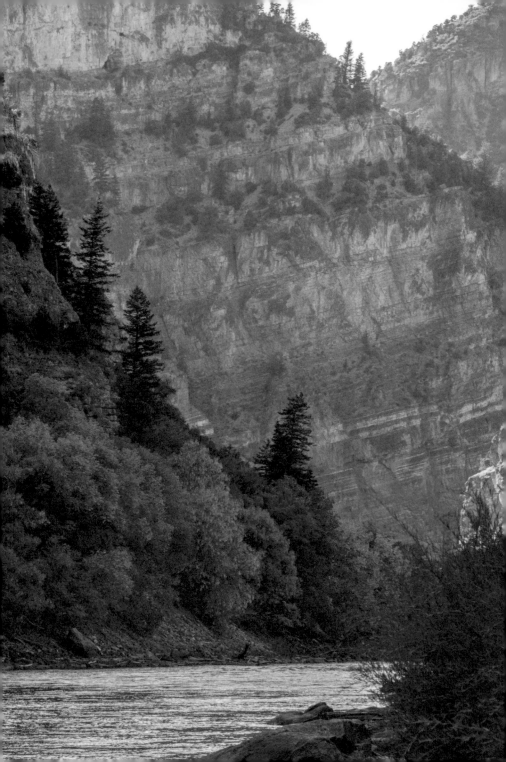

Ephemeral

Before the mountains were born, before you gave birth to the
earth and the world, from beginning to end, you are God.
PSALM 90:2 NLT

The rock formations of the mountain ranges hold ancient secrets: stories filled with mystery and power and time. You search their stone faces for clues, trying to understand it all.

These rocks tell of mighty shifts in the earth's crust, tectonic plates colliding, folding, pushing up, erupting, and eroding to form the great landscapes of the planet. Their layers hint of that invisible force called "deep magic" in the mythical tales of Narnia, and looking at them, you can almost imagine a low hum of irresistible power beneath the surface.

Driving on roadways blasted into being through dynamite and jackhammers on mountainsides and gorges, you notice the strata of exposed rock, itself a journey into the past. Like a time traveler, you delve deeper and deeper into the creation story of a world in motion and of a God who has displayed His infinite power across eons of being.

Your existence is ephemeral.

Psalm 90, the oldest known psalm, is attributed to Moses. The one who had seen God's glory penned words that echo through time and resonate with our human experience against the backdrop of eternity.

For you, a thousand years are as a passing day,
as brief as a few night hours.

You sweep people away like dreams that disappear.
 They are like grass that springs up in the morning.
In the morning it blooms and flourishes,
 but by evening it is dry and withered
(Psalm 90:4-6 NLT).

You feel it: You *are* a blade of grass, here for a moment and then gone. Standing next to a wall of striated granite, your life on earth takes on a new perspective.

Brief.

Vaporous.

Small.

And yet the psalm points your attention to something bigger: Understanding the brevity of our lives *shouldn't* cause us to feel hopeless and insignificant, but instead it gives us a sense of urgency to make our lives count. "Teach us to realize the brevity of life, so that we may grow in wisdom" (verse 12).

Still small, still vaporous, still brief . . . yet focused on living fully for Him each day. Verse 14 beautifully summarizes this ancient prayer that sits comfortably with ancient rocks: "Satisfy us each morning with your unfailing love, so we may sing for joy to the end of our lives."

Teach us to realize the brevity of life,
so that we may grow in wisdom.
PSALM 90:12 NLT

Ache

First snowfall.

The leaves are trimmed with a sparkle of loveliness, an angel kiss of ice, a bit of nature tinsel to decorate the landscape. As the rising sun lends its rays to the glittering couture, the fleeting stardom causes you to catch your breath in wonder.

"Ahhh." Breath forms around your lips and lifts away.

The fairy garden glistens with fleeting magic, or so it seems in your mind's eye. If you blink, it might all be gone . . . and so you stand motionless to capture it a moment longer.

Everything, like a cherished memory, is perfect. It feels frozen in time, caught in the spun wool of the imagination. You've come here for this: to remember life's sweetness and to renew your desire for more.

So much of life happens in tiny, fleeting moments that catch our breath and then vanish, leaving us with a wistful pang, a longing to experience something that lasts. An eternal joy, a timeless sense of peace.

Shalom.

That's what we long for.

"Shalom" is a Hebrew word that means

> the webbing together of God, humans, and all
> creation in justice, fulfillment, and delight. We call
> it peace, but it means far more than mere peace of
> mind or a cease-fire between enemies. In the Bible,
> shalom means universal flourishing, wholeness, and
> delight—a rich state of affairs in which natural

needs are satisfied and natural gifts fruitfully employed, a state of affairs that inspires joyful wonder as its Creator and Savior opens doors and welcomes the creatures in whom he delights. Shalom, in other words, is the way things ought to be.[10]

We ache for this kind of shalom, for the way things ought to be. God has put this longing in our hearts so that we will work for the flourishing of the world, to see all of creation living in wholeness and delight.

The morning frost reminds us to see the kingdom of God in every moment, and to be willing instruments of shalom.

Who is the mother of the ice?
Who gives birth to the frost from the heavens?
JOB 38:29 NLT

Behold, I will extend peace to her like a river,
and the glory of the nations like an overflowing stream.
ISAIAH 66:12 ESV

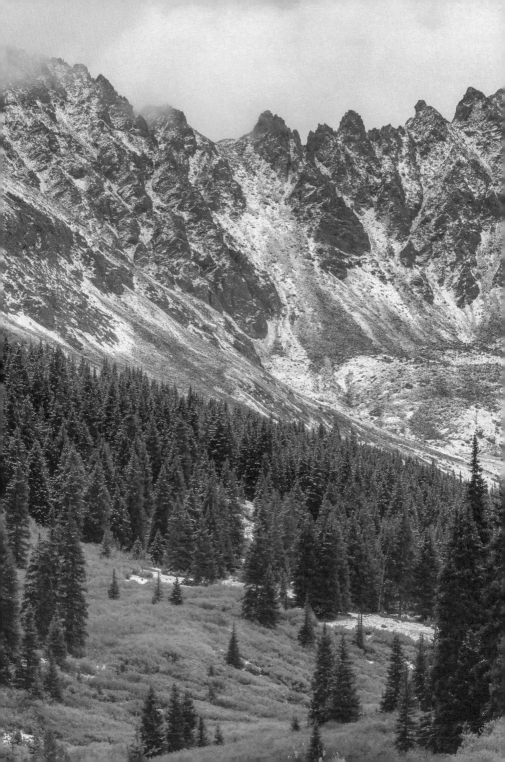

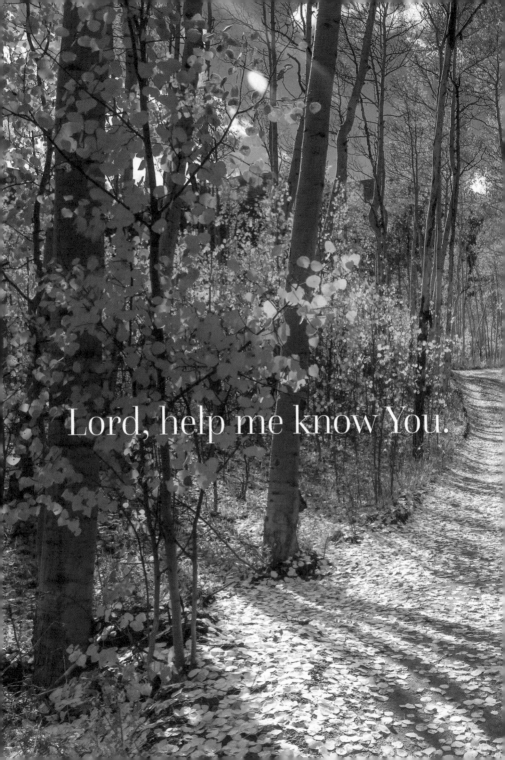

Lord, help me know You.

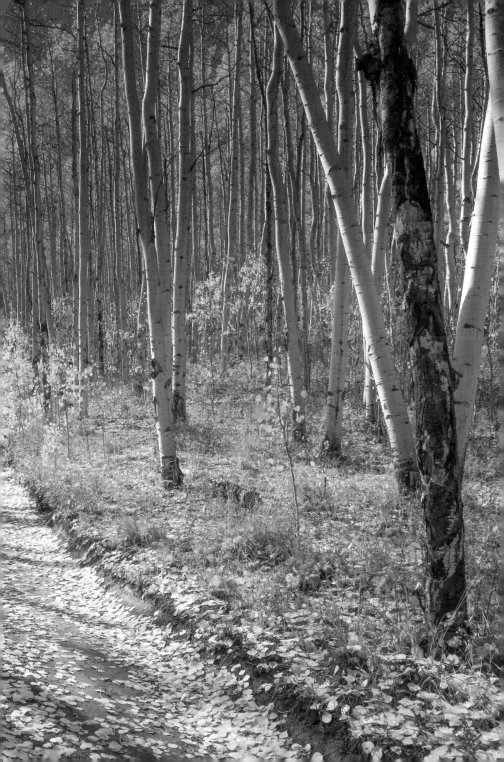

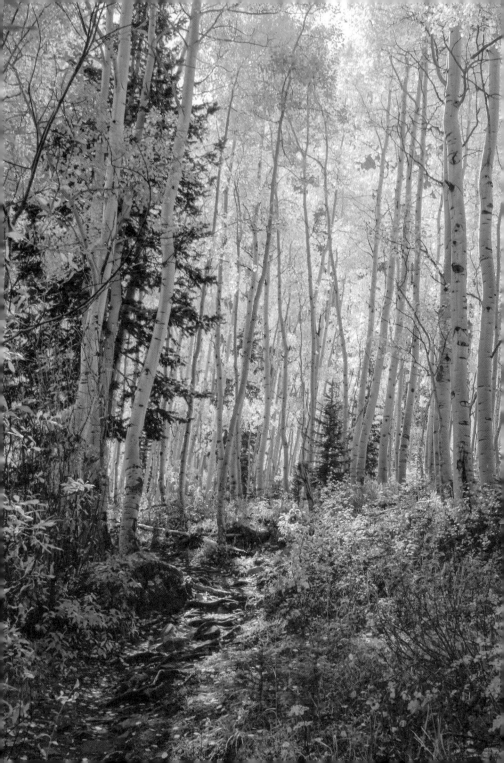

Pilgrimage

The blister on your heel is signaling that it's time to take a break.

You've been hiking since sunup, and now at midmorning a granola bar and water, along with a fresh bandage for your heel, is just what you need.

You find a suitable log to sit on and dig through your backpack for snacks and your first aid kit. Removing your hiking shoes, you wish you'd taken the time to break in this new pair like you were advised to do when you bought them.

Hindsight is twenty-twenty.

One heel has an angry red blister; the other looks like it's just annoyed. You know it will be in a full rage by the time you reach your destination, but you are undeterred.

This is a pilgrimage, after all.

As a teenager, you hiked this trail to the hidden lake at the end, and now you've returned after years of absence. The small lake holds a sacred memory: It was there that you first felt a calling to commit your life to God. That day, you were overcome by the beauty and wonder of creation, stunned by a Creator who was both immense and personal.

You knew Him in a simple yet profound way.

People often talk about mountaintop experiences as if they are not real. They say that being moved by emotion to make a spiritual commitment cannot last.

But you know differently.

That day changed the trajectory of your life. You made decisions

based on your confession of faith and dedication to a divine calling. You had high hopes and an overwhelming sense of peace, a calm awareness that God was with you and would make your path successful.

Now, all these years later, you don't doubt the experience, but life has been so much more complicated than you expected. Success, or whatever you thought you'd achieve, didn't happen the way you thought it would. You've come to acknowledge that perhaps you misunderstood what following Jesus would look like. You were just a kid back then.

With fresh bandages applied (along with dry socks), you gingerly resume your hike. Even at a slower pace you should reach the lake by lunchtime, and you're grateful for the extra time to take in the woodland scenery and reflect on your journey.

You are returning to a place of spiritual significance.

What will it hold this time?

With each step your purpose becomes clearer: This isn't about evaluating your success as a Christian but about reaffirming your commitment to the Way.

The peace you *felt* as a brand-new Christian has mellowed and deepened into an understanding of what it means to *be* a Christ-follower. Though the lake is still an hour away, the bruises on your heels are reminders that difficulties are part of the journey. No pilgrimage is complete without the desire to give up, turn around, and go home.

You reach the top of the last embankment and stop to take in the scene. The lake is unchanged, still breathtaking in its stark beauty.

Still hidden, still alive with wonder.

It is *you* who have been changed, not by the place itself but by the sacred journey to get here.

Blessed are those whose strength is in you,
whose hearts are set on pilgrimage.

PSALM 84:5

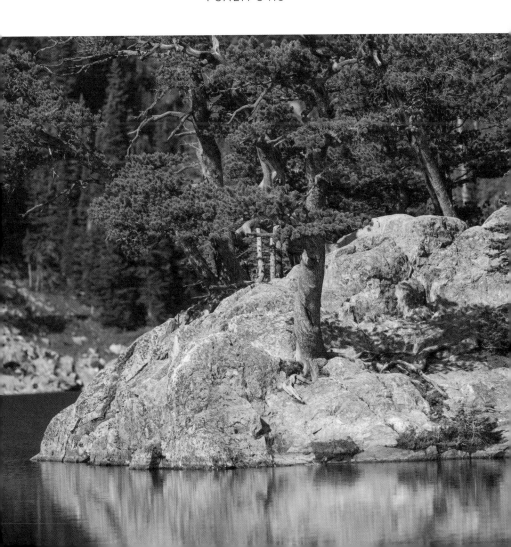

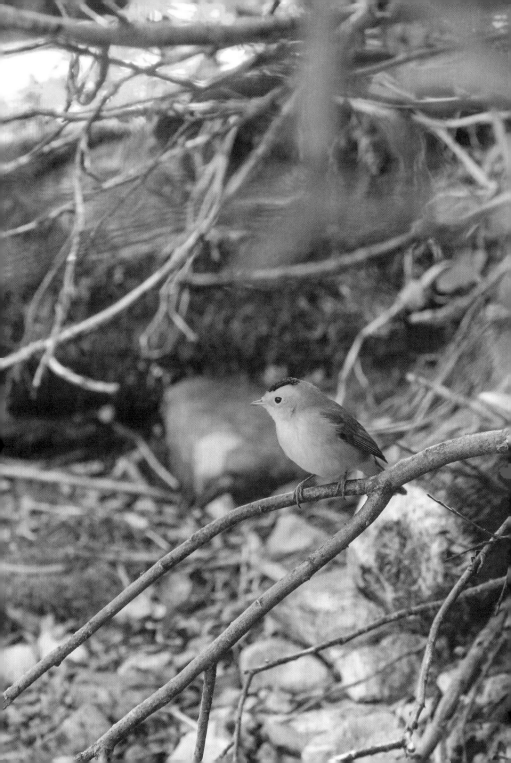

Praise

You hear her long before you see her.

High, clear notes let you know that she is somewhere in the thicket nearby.

A flash of bright color catches your eye, and you see where she is perched among the low brush in the woodlands at the edge of the clearing.

A yellow warbler. With her dandelion body and fine brown wings, this tiny bird fills the mountain sanctuary with her big voice.

She calls and then tilts her head to listen. She pecks at leaves and ruffles her feathers as she awaits a reply. The meadow is alive with chirps and buzzing—a myriad of birds, insects, and frogs have convened a coffee klatch to discuss the weather, argue over territory, and preen in the sun. She ignores the chatter, keen to hear the one sound she is listening for.

Above the din, her bright call rings out once again, a lilting tune that finishes in a question mark. *Are you there? Will you join me?*

From the far side of the stream, a reply: *Tweet-tweet-tweet-tatatata-tweet.*

Here I am, he sings. You are unable to see him, but his lilt is an unmistakable match. *I will join you.*

Your yellow warbler hops to a higher branch and throws back her head, now singing with all her might, delighted to find a duet partner.

Back and forth, they sing from their hymnals by memory, a song they know by heart.

An entire choir, robed in finery, fills the woodland clearing with praise.

Tweet-tweet-tweet-tatatatata-tweet.

Tweet-tweet-tatatata-tweet-tweet-tweet.

Call and response, call and response.

The birds sing the songs of nature in a true gospel-song form: They echo their adoration of the Creator in celebration of community.

Caught up in their song, you hear branches provide rhythm, frogs lend bass, bees add percussion, and robins punctuate the pauses with their own *cheer-cheer-cheer-up* call.

An entire choir, robed in finery, fills the woodland clearing with praise.

Your own song of praise bubbles up from deep within as you hear His call: *Are you there? Will you join Me?*

Your soul responds in simple, unadorned worship—a song you too know by heart: "Bless the LORD, my soul, and all that is within me, bless His holy name" (Psalm 103:1 NASB).

The birds of the sky nest by the waters;
they sing among the branches. . . .
I will sing to the LORD all my life;
I will sing praise to my God as long as I live.
PSALM 104:12,33

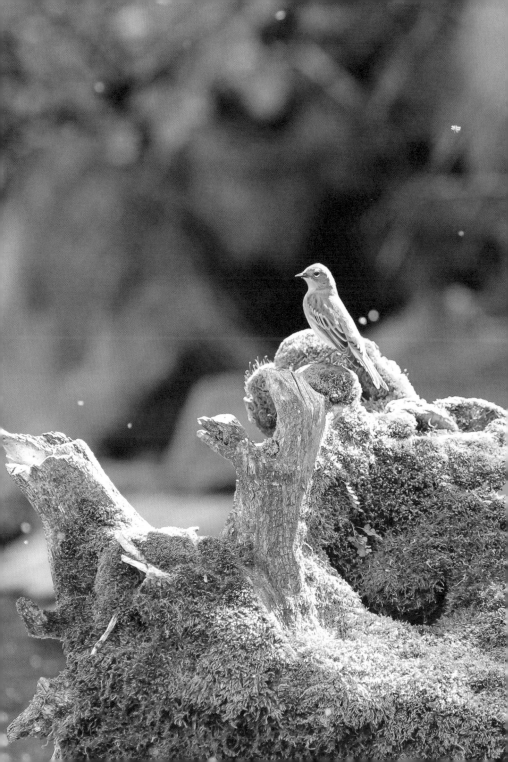

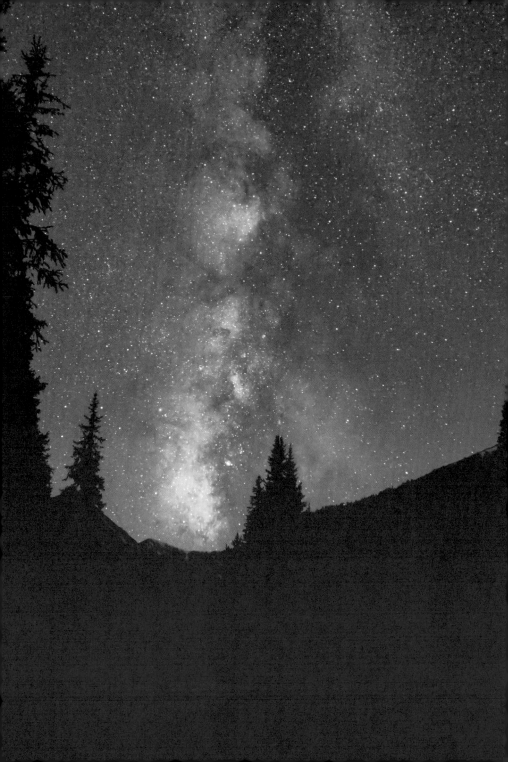

Darkness

The sun drops like a stone behind the west ridgeline, bringing dusk earlier than you anticipated. You feel the air temperature plummet, and you realize there is still much to be done before night falls on your camping preparation. A hasty gathering of firewood, setting up stoves, unpacking your backpack, adding the rainfly to your tent.

Finally, a simple dinner of scrambled eggs and bacon, with a side of hash browns, makes a delicious meal. Breakfast for supper has never tasted so good. By the light of the campfire, the deepening darkness around you feels like a cocoon, and you are reluctant to leave it. But it's the end of a day filled with activity at an altitude you're not accustomed to, and exhaustion seeps into your bones like an incoming tide. That sleeping bag is calling your name.

You push the hot embers apart to snuff the fire, and that's when the darkness makes its presence known. With clouds obscuring the moonlight, what felt like a cocoon only moments ago now pushes in as a foreboding companion—inky blackness that touches your skin with a cold breath of fear.

Being alone at night in the wilderness brings its own kind of terror. Trees seem to take on ominous forms, while sounds of snapping twigs cause your imagination to run wild with visions of bears, mountain lions, and intruders. You begin to wish for the comfort of people in proximity. *How long would it take to get to the car and make an escape?* You question the decision-making that brought you here in the first place. *Where are You, God?*

> "I've pitched my tent in the land of hope."
> —ACTS 2:26 MSG

Fear of dark unknowns is not new to you, but now there is only thin nylon fabric with a zippered door between you and the darkest unknown you've ever experienced. Your ears strain for sounds of footsteps. Your hand reaches for your pocketknife, just in case. You are hopeless, helplessly alone, afraid to move.

Saint John of the Cross, a sixteenth-century monk who worked to reform his Carmelite order, wrote about a dark night in which a soul despairs.[11] Kept in a small, windowless jail cell for months, given nothing but bread and water to eat, John came to understand the dark night as a necessary part of the soul's union with God. The dark night of the soul represents the painful times of anguish we go through when we experience loss, disappointment, failure, trauma, and fear. It is a journey in which we empty ourselves of selfish ambition, cares of the world, sinful desires, and our own attempts to attain perfection. Through his poems, John encourages us to learn to calm our spirits, to lean into God's presence even when we do not sense His nearness. He reminds us that God's love is never removed from us, no matter how dark the night.

In this moment, all you can do is trust that God sees you, hears you, and knows you. He bathes your small tent in love, and you relax your grip on the pocketknife with an overwhelming sense of surrender to His compassion. The thick night around you is only temporary and cannot hide you from God's faithful love. Psalm 139:12 reminds you that even the darkness is as light to Him.

The warmth of your sleeping bag and the lull of a nearby stream eventually cause your eyes to close as you rest in the presence of His Spirit, ever with you in the darkest of unknowns.

Morning will come.

I saw God before me for all time.
Nothing can shake me; he's right by my side.
I'm glad from the inside out, ecstatic;
I've pitched my tent in the land of hope.
I know you'll never dump me in Hades;
I'll never even smell the stench of death.
You've got my feet on the life-path,
with your face shining sun-joy all around.

ACTS 2:26-28 MSG

Goodness

"In the beginning, God created the heavens and the earth"—so go the familiar opening words of the creation story. In its poetic telling, creation unfolds from formlessness into a world teeming with life and beauty. With each day's completion, God looks over His work and declares that it is good.

The account ends with a satisfied flourish: "God saw all that he had made, and it was very good."

Day and night.

Sky.

Sea and land.

Plants and trees.

Sun, moon, and stars.

Birds of the air and fish of the sea.

All the land animals.

Human beings, male and female, made in God's image.

Very good.

Every part of creation brought delight to the Uncreated One.

You fill your lungs with the clear mountain air and look out over the scene before you. All of creation sparkles with the goodness of God.

When you're in the mountains, you cannot help but be amazed by God's craftsmanship. As foothills give way to rugged peaks, deep valleys and verdant meadows provide habitat and food for earth's creatures, and alpine snowmelts produce water for streams and lakes, you are overwhelmed with a world that exudes lavish generosity and goodness.

A good God.

A good creation.

It cannot be by chance that the Bible opens with this foundational revelation of the kind of God He is and the kind of work He does. Perhaps, as the story was recited aloud around campfires, then copied onto scrolls by candlelight, then printed on pages, then produced in modern forms, it's so people throughout all ages would wake to a memory of goodness that was imprinted on our souls from the beginning. Like a seed long buried, there is an inner knowing that bursts open at the remembrance of it. We yearn for this goodness, not as some fantastical myth but because we are created for it.

"Surely your goodness and love will follow me all the days of my life," David once said from a green meadow like this one, where he led his ewes and lambs by still waters (Psalm 23:6). He spent his days outside, communing with a God he knew to be good. David must have known he could never outrun or outdistance God's goodness because it was all around him.

We wake to a memory of goodness.

God saw that it was very good.

Our hearts are filled with gratitude as we explore the delights God created. His goodness and love shall follow us all the days of our lives.

I remain confident of this: I will see the
goodness of the L ORD in the land of the living.

PSALM 27:13

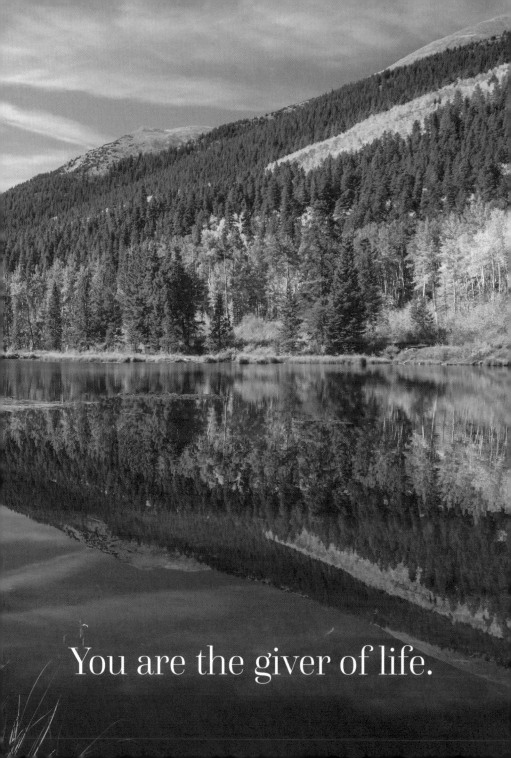

You are the giver of life.

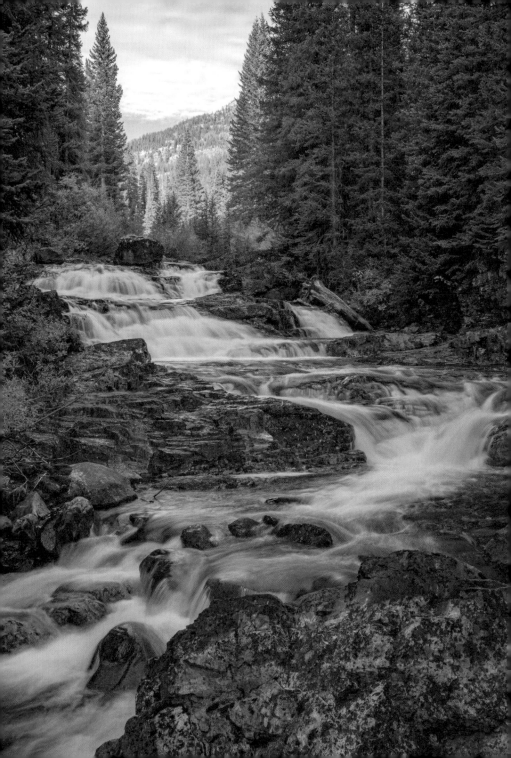

Grief

The bend in this river is the only place you can think of to grieve the way you know you need to grieve. You run the last ten yards to reach the bank and fall to your knees at the edge of the torrent and howl into the deafening roar.

You've held it in for so long, but now the flood of grief that you've kept at bay has burst through.

The dam has broken.

You *need* the fury of rushing water to drown out the sound of your own furious cries. Crashing into the boulders at the river's edge, the water roils past, foaming and lashing—devouring logs and earth and flotsam in its hunger to be free of its banks. It eats at its boundaries with ravenous desire, and you love it for its relentless appetite.

No one can hear your sobs over the rush.

It is safe here to scream without fear of being overheard.

Or lectured.

Or judged.

And so you scream.

The icy mountain river roils with pent-up obsession for the lowest point in elevation. It will not stop until it is entirely spent, emptied of its anger, its violence, its grief. Yes, there will be a placid ocean at the river's end—this you know—but here in this moment there is nothing but rage.

How could You, God?

How could You let this happen?

You have been nothing but faithful, loyal, obedient. You've sacrificed and worked for His glory . . . and now *this*? You cannot contain the flood that threatens your carefully assembled borders and tidy walls, meant to keep the current manageable, fixable, controllable.

Your sobs subside long enough for you to hear the hiss of spray against the shore, the rumble of boulders being rearranged at the depths, the bubbles of fear at the surface.

Let the current carry me.

I can't fight this anymore.

I don't know who I'll be at the river's end.

The moment of surrender leaves you weak, spent, still on your knees before the power of gravity on water. This river of grief has pulled you under, pummeled you, and left you for dead . . . yet here you are.

Still breathing.

Your rage settles into a hollow near-acceptance.

This is not how I thought it would be.

Beyond this tumultuous bend in the river, the landscape levels out into a wide plain. This same river that has given voice to your pain will one day give space to a gentle flow of healing and open seas. That place is for another day, another time, and you can rest knowing that one day your journey will take you there.

Until then, this river bend holds your pain, just as God holds everything you throw at Him. He is not afraid of your rage, does not

judge your anger, and will not turn away from your grief. He is present in the torrential flood that eats at the banks of what you thought you knew and reshapes the riverbed of your faith into something new. He hears your cries amid the deafening roar.

The mighty river breaks your boundaries and flows, unstoppable, to an ocean as wide as God's outstretched arms and as deep as His endless love for you.

Nothing . . . will ever be able to separate us from the love of God that is revealed in Christ Jesus our Lord.

ROMANS 8:39 NLT

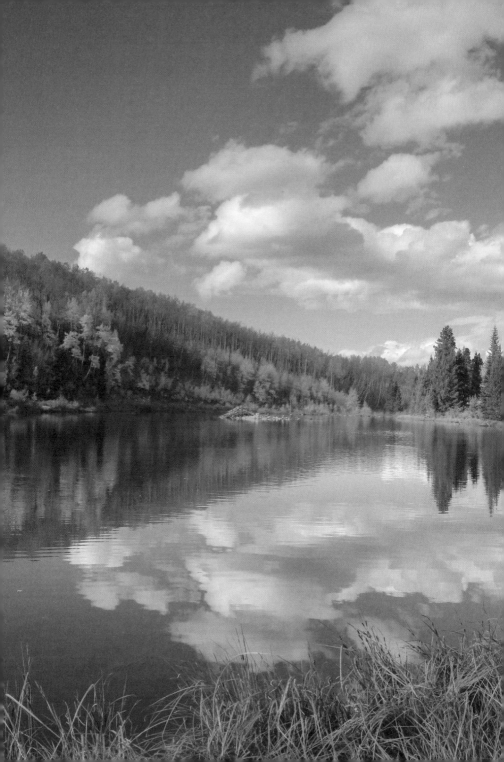

Free

You wake to the sound of an email arriving in your inbox. The phone on your nightstand dings, making you feel "late" to start your workday, even though it is only 6:45 a.m. *Sigh.* You were up late, answering emails on your laptop from your bed, and here you are once again.

Even my bed is no longer restful.

Nearly every waking hour, we are bombarded with news, information, opinions, images, opportunities, worries, and work. Even at night, our sleep is interrupted with incoming calls and texts, reminders, and bad weather and missing person alerts. Mental health terms keep expanding in order to keep up with the kinds of stress humans are experiencing.

Information overload.

Compassion fatigue.

Social envy.

Fear of missing out.

Constant checking.

Despair.

Sleeplessness.

Anxiety.

Depression.

Life in the digital age is exhausting.

It's no wonder *you* are exhausted.

How can I regain my sense of peace?

How can I break free from this technological hamster wheel I'm on?

The words of Wendell Berry's "The Peace of Wild Things" come to mind:

> *When despair for the world grows in me*
> *and I wake in the night at the least sound*
> *in fear of what my life and my children's lives may be,*
> *I go and lie down where the wood drake*
> *rests in his beauty on the water, and the*
> *great heron feeds.*
> *I come into the peace of wild things*
> *who do not tax their lives with forethought*
> *of grief. I come into the presence of still water.*
> *And I feel above me the day-blind stars*
> *waiting with their light. For a time*
> *I rest in the grace of the world, and am free.*[12]

The peace of wild things who do not tax their lives with fore-thought of grief.

The presence of still water.

The grace of the world.

Reading these words brings a wistfulness for a simpler life, one in which you could walk out your door and into a landscape of still water, and wood drakes, and day-blind stars.

This is what I need.

Even Jesus needed to disconnect from the noise and find solitude in the wilderness. It was there that He prayed and communed with

His Father. It was in the untamed spaces that He regained His peace and sense of direction. You have to laugh at yourself, thinking that you can manage it all just fine when Jesus Himself needed time alone in wild places in order to be fully alive in His life and mission.

And so you unplug. You silence your phone. You set some digital boundaries.

You plan a trip to the mountains and write it on your calendar.

Then you step outside into the kind of nature that is available to you today—a quiet park that offers a slice of the grace of the world.

For a time, you are free.

And it is enough.

> Jesus Himself would often slip away
> to the wilderness and pray.
>
> LUKE 5:16 NASB

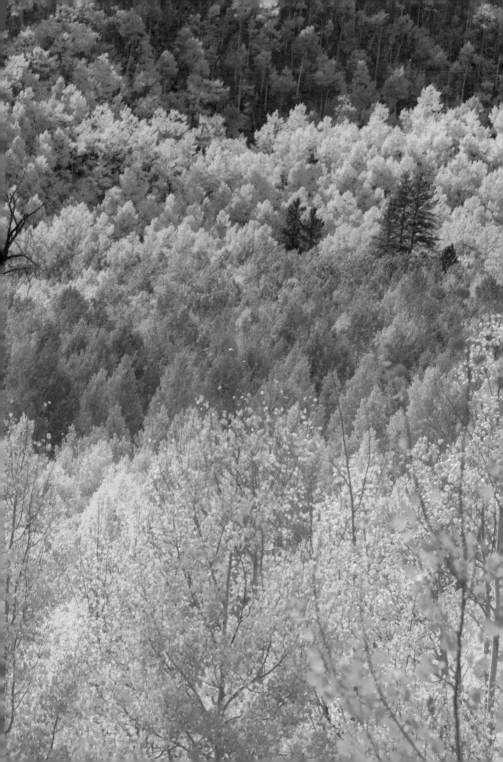

Perspective

The shimmering leaves of the aspens in autumn seem to whisper your name. Their irresistible invitation to come and sit among them pulls you up a dirt road that hugs the curves of the mountainside, to a spot that holds promise of an afternoon well spent. You can imagine no better way to spend today.

From the road below, the aspen grove looked like a solid mass of color: gold, fiery red and orange, bright yellow. You imagined that you'd have to bushwhack through the dense forest to find a place for your blanket. But now as you approach the grove, you can see how each individual tree is gracefully spaced from the others, with plenty of room in between for tall grasses and small pines to feel the warmth of the sun through dappled leaves.

It is a cathedral of trees.

You turn in all directions, awed by the sanctuary that surrounds you. Each white trunk lifts its branches like arms raised in adoration to the Creator. Above you, they touch and sway in a gently moving canopy that drops a confetti of leaves with each gust of wind.

You are struck by how, from your earlier far-off vantage point, this forest looked so massive and formidable that you couldn't see *one single* individual tree.

But from here, right up close, you see how each aspen has its own space—with plenty of room to flourish—and each has its own uniquely patterned trunk. It is only far above your head that their branches touch and interlock to create that glorious cathedral ceiling.

You are reminded how our vantage point makes all the difference. Forests. Trees. So often we are blinded by one for the other.

It is so easy to miss the forest for the trees . . . or get so wrapped up in the trees that we miss the forest they are creating.

Often, we are so focused on the obstacles we face that we miss the grace God is providing for us to get through them. Or we're so intent on some future goal that we don't notice the small blessings along the way.

Sometimes we find ourselves facing something that seems just too big to handle, and we can't make sense of it all. Or maybe we have a vision for our life that feels unattainable, unreachable. We can see the solid mass of forest but not the trees it will take to make it.

You breathe the crisp air and offer a silent prayer for the wisdom to see the forest—or trees—that will make all the difference in how you view your circumstance. You can trust Him to show you the details you've been missing and to give you a grand view of what He is creating in and through you.

His beautiful plan is unfolding even now.

As the heavens are higher than the earth,
so are my ways higher than your ways
and my thoughts than your thoughts.
ISAIAH 55:9

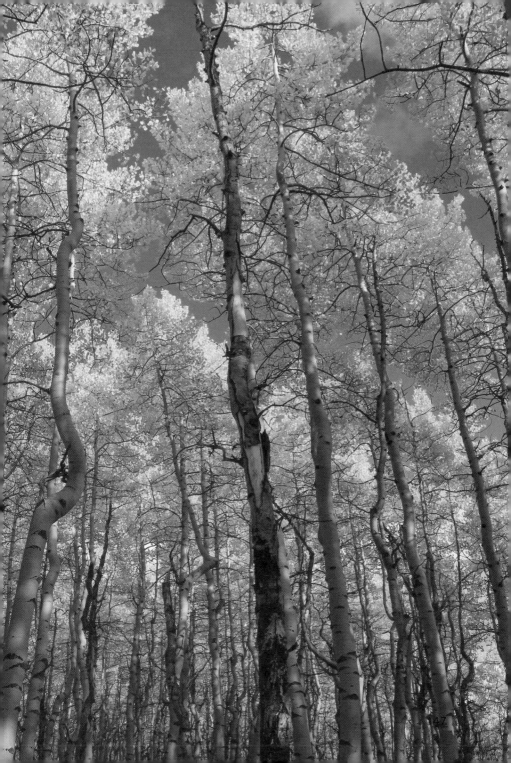

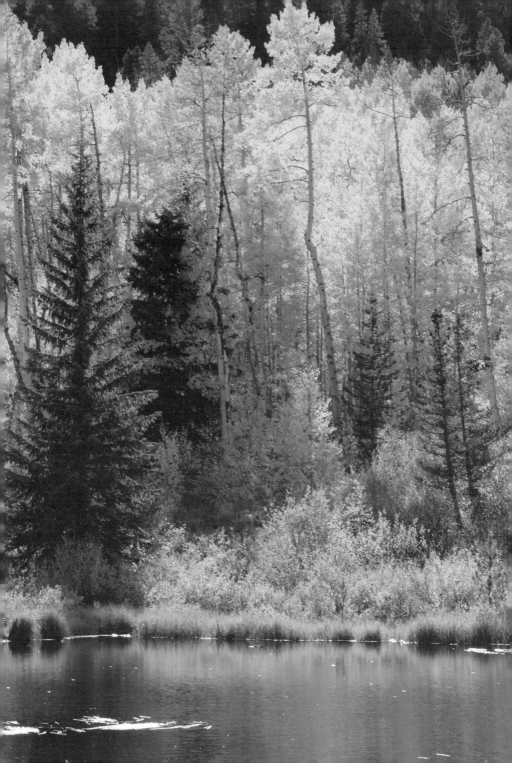

Grace

It's church in the mountains of Colorado.

Normally you'd be in your "regular" church on this Sunday morning. You'd be participating in a worship service, volunteering, welcoming people into the sanctuary, and listening to the pastor preach a sermon.

Nature preaches a sermon that echoes off rugged cliffs and into the valley below.

"Grace upon grace," murmur the bubbling streams that feed the still lake.

"God with us," whispers the *shhhh*-ing of the aspen leaves as the wind picks up their voices and scatters them upon the earth.

God with us. Grace.

Despite the turmoil of this world and the problems that seem unsolvable, God's presence is still with us. His grace is still at work to draw us near, to let us hear and know and see the Almighty One.

Yes, you believe that, but sometimes . . . you forget.

Sometimes it takes a special trip to the mountains to remember what your heart already knows.

You've had church in many places: You've worshipped while washing dishes. You've met God at your mailbox. Your car is one of your favorite places to pray. Of course, gathering with other believers—anywhere—is church. You've experienced church in arenas with ten thousand people singing together. You've had church in your living room with an open Bible and a cup of coffee. Sometimes church

Sometimes it takes a special trip
to the mountains to remember
what your heart already knows.

comes when you can snatch a minute away from the busyness of regular life.

But the church you love best is in nature. It is here that you are face-to-face with the mystery—and mastery—of God Himself. Today, you sit in silence and watch the sunlight chase clouds over the mountain peaks and ignite the aspens with vivid color. No words can capture the sense of wholeness, the wholeness of *being*, when you're here.

You breathe in and close your eyes and still your heart.

As you turn to leave, your eyes fall on a heart-shaped rock at the edge of the stream. You tuck it in your pocket as a reminder of this moment in God's magnificent sanctuary. Maybe angels above are singing—you don't know. Maybe it's just your heart that fluttered at this perfect little find. Maybe there's a message in it for you somewhere—who knows?

But this you *do* know: Grace upon grace, God is with us still.

From his fullness we have all received,
grace upon grace.
JOHN 1:16 ESV

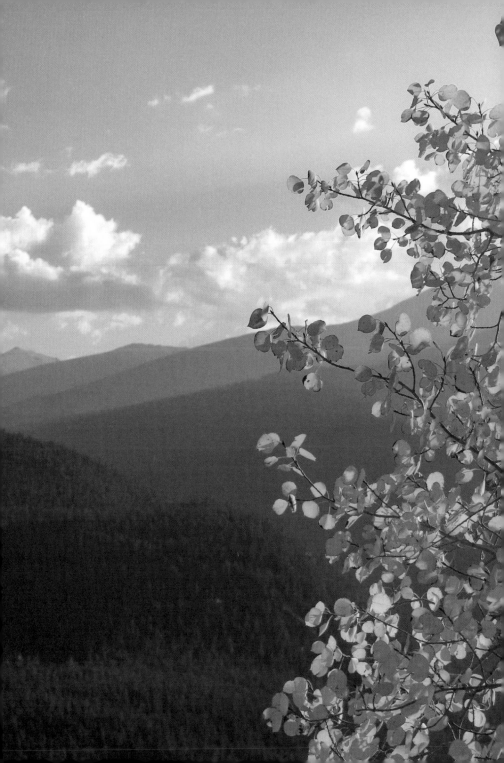

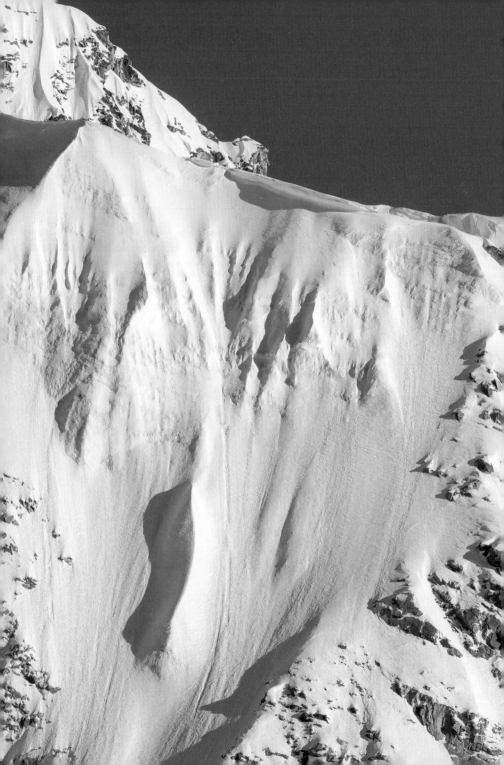

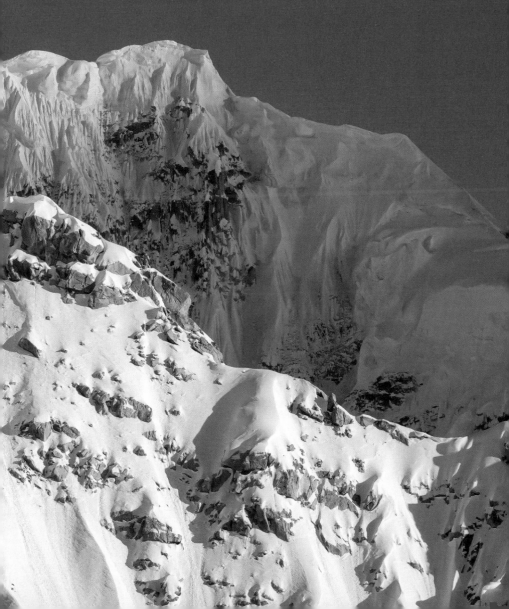

Your love is higher than the mountains, God.

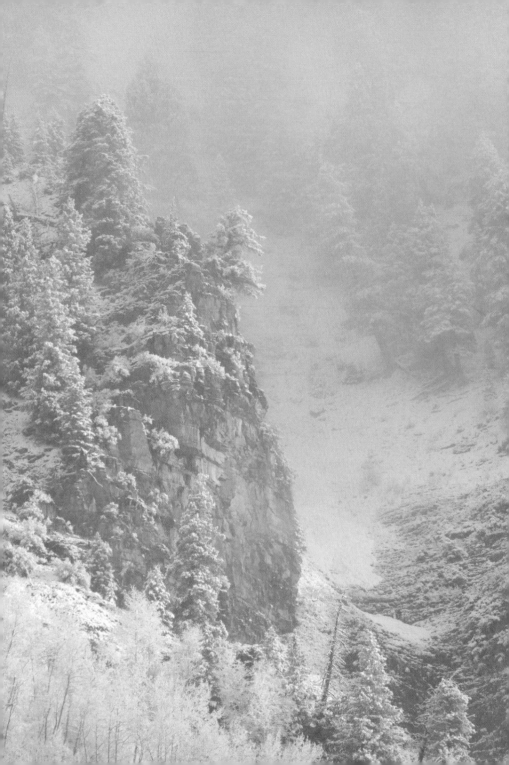

Accepted

Seasoned mountaineers have a common saying: "The mountains don't care." Their years of experience in the alpine wilderness have shown them the seemingly indiscriminate nature of avalanches, sudden storms, high winds, rocks that fall or give way, and all the random things that happen in this environment. They've seen too many hikers become disoriented and lose their way—and they've pulled too many young climbers from avalanches of snow—to have a cavalier attitude about safety and preparedness. The allure of breathtakingly beautiful scenery has lulled many people into thinking that the mountains are benign.

In truth, mountains are anything but benign. That may seem shocking but, you hasten to add, neither are they malevolent. The mountains are simply impassive: They don't care whether you are good or bad, religious or irreligious, intending to harm or to help. What happens on the mountains will happen regardless of who you are.

You ponder this as you take in the peaks before you. The tips shine pink in the first light of day, looking ever like fairy castles in the far-off distance. You are bundled from head to foot in layers of wool and thermal wear. Your toes already feel the bite of cold, and you're positive this morning's snowshoe trek will be a challenge.

But knowing that the mountain doesn't care brings a strange sense of peace. It is a rare experience to show up to a meeting that has no agenda, no expectation, and no need to present your best self. Today you will not need an advanced degree from a prestigious university to meet with this mountain. You will not need to make sure your clothing

is professional—or even coordinates. You silently thank your cousin for the borrowed yellow hat and the purple gloves. This is about being present, not personal presentation.

Being present to a mountain that you cannot impress or disappoint gives you freedom to let down your guard. What will you do when there is no ego to contend with, no embarrassment or shame? You could make snow angels, as many as you'd like. Imagine you, an adult, playing with such abandon! You could make a snow cave or a snowman or see how far you could throw a snowball. Or you could listen to snowflakes fall, admire the beauty of a secluded hollow, or sit on a stump near a frozen creek and simply *be*. Whatever you choose, there is no judgment of right or wrong, better or worse, silly or mature.

Being released from self-consciousness brings an acute awareness of how much effort we exert in the pursuit of people-pleasing. From lawn maintenance that rivals the neighbors' to choosing what kind of car to drive, what to wear, what to eat, with whom to associate, what version of Bible to read . . . nearly everything we engage in maintains an ambient, low-level hum that wonders, *Is this acceptable?*

But the mountains don't care.

And neither does God.

Come as you are.

Accept each other just as Christ has accepted
you so that God will be given glory.
ROMANS 15:7 NLT

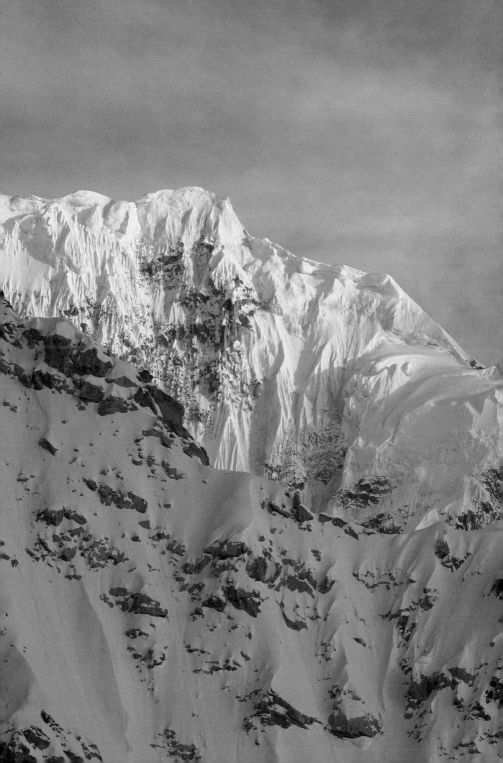

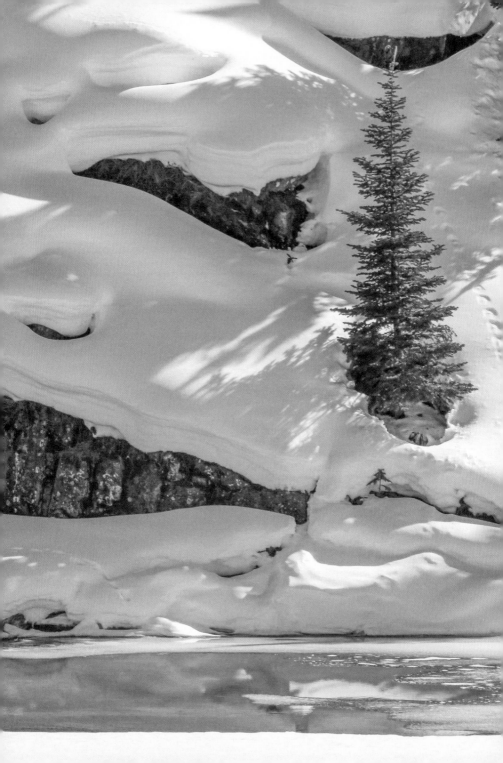

Rest

Fresh snow blankets the wild landscape like a down quilt. Feathery snowflakes fall aimlessly and drift upon the craggy rocks, the gnarled trees, and the rough brush, softening their edges and cajoling them to sleep.

Sleep now. Hush.

Winter arrives gently this year.

The untamed place reluctantly acquiesces to rest, like a wild child who resists a nap and finally stills just long enough to succumb to slumber.

Leaves are fallen; branches, quiet.

The stream is frozen, its babble shushed midsentence.

Mountain heather is tucked under a snow cover, her nodding heads on snowflake pillows.

Everywhere, creatures find dens and hidey-holes, thickets and caves to snuggle into.

A long winter nap beneath this spun-wool blanket brings a necessary pause, a dormancy by design for a wild world that needs its rest.

You turn in a slow circle, taking it all in. The beauty of stillness is a sacred pause, a holy hush, a divine season of *mise en place*. Everything in its place, preparing for the next season of growth, motion, and life.

You sense that you have been in your own season of dormancy, of waiting. But it hasn't felt beautiful; it has felt cold and dead. You've witnessed others around you, their lives and ministries full of vibrant life while you've ached to throw off your weighted blanket of winter

slumber. Your dreams have been frozen, your progress impeded, your path obscured.

Now the sparkle of fresh-fallen snow gives you a new perspective.

What if my life needs seasons of rest, just like the earth needs it?

What if God's designed it so that I must stop and be still?

Winter is not the end of life but a necessary part of it. It's a means of protecting, prolonging, and preserving fruitfulness and regeneration. You can see that now.

My soul is a wild child needing rest.

You turn, one last time, and surrender to the season.

My Presence will go with you, and I will give you rest.

EXODUS 33:14

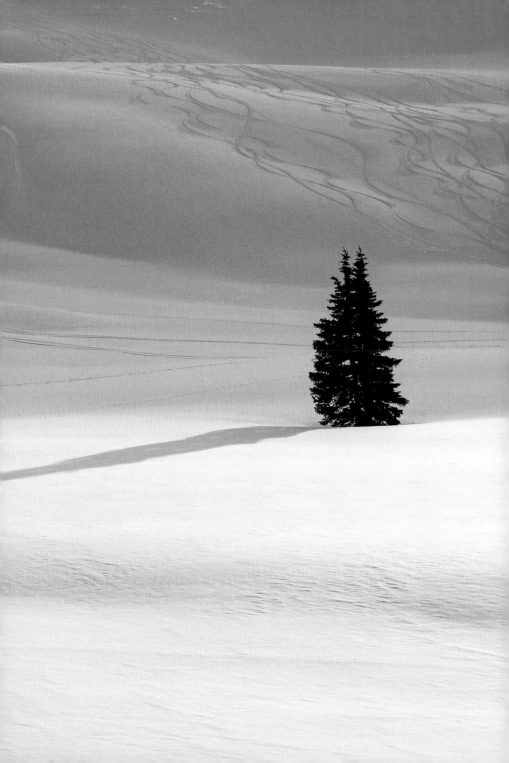

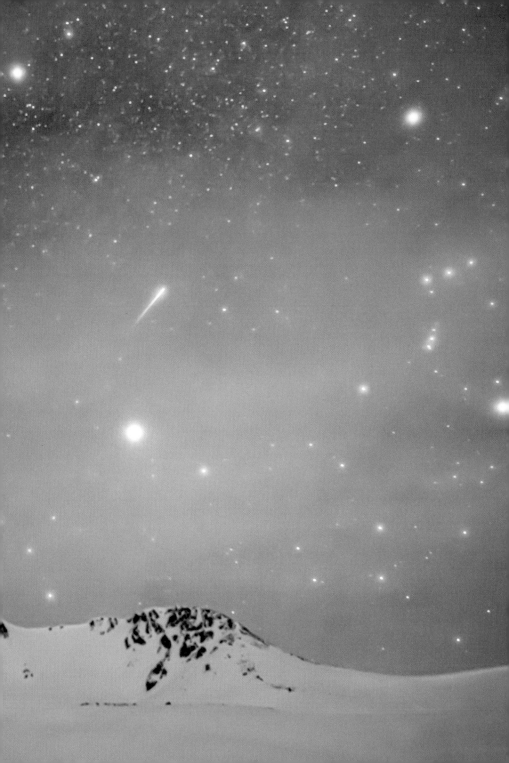

Mystery

Lift up your eyes and look to the heavens: Who created all these?
He who brings out the starry host one by one and calls forth
each of them by name. Because of his great power and
mighty strength, not one of them is missing.

ISAIAH 40:26

The sheer number of stars that you can see with your naked eyes on this cold, clear night leaves you in disbelief. Here, away from the light pollution of cities, highways, and illuminated signs, the sky is so bedazzled with innumerable twinkling lights that you cannot believe this is the same night sky that is above you in your regular suburban life. In fact, you normally feel lucky if you can point out a handful of stars, like the Big Dipper, at night.

You've gotten used to a nighttime without stars.

But this!

Are there always this many?

"Always," someone in your stargazing group answers.

How many stars *are* there?

"In the observable universe? Over ten billion trillion."

It feels like you can see every one of them. When you are told that only about four thousand stars are visible to our human eyes, you simply cannot comprehend the magnitude of what's beyond you.

Many of us live lives oblivious to stars. Distracted and hurried, we make midnight runs to twenty-four-hour supercenters, parking under

floodlights in enormous parking lots. We drive home and pull into our garages and draw the window blinds closed against the streetlights. We exist unaware of the wonders beyond our man-made canopies of artificial light.

Now you find yourself swallowing a lump in your throat as you gaze up into the heavens. It's like you've been living as a pauper, only to discover a treasure that's been behind a curtain the whole time. All you had to do was open it. On the other side of the curtain is the richness of awe and wonder and an excitement that comes when you realize just how small your ideas are—and how much there is yet to learn. You have crossed a threshold to curiosity and limitless possibility.

Your group of stargazers is hushed. They, too, feel humbled by the immensity of the universe. There is small chatter about how many light-years it takes to cross it (forty-six billion) and a quiet discussion of dark matter and the intricate web of gravity, but mostly there is silence as you take in an infinite reality not easily grasped by our human minds.

T.S. Eliot once wrote,

> We shall not cease from exploration
> And the end of all our exploring
> Will be to arrive where we started
> And know the place for the first time.[13]

A cup of hot cocoa is offered, and sips of the sweet liquid send

warmth through your body on this winter night. The poet's words describe the alchemy of discovery and knowing, a curious mix that captures your own quest for the Divine. In your search for answers to life's biggest questions, you are amazed to find that your journey takes you not to a set of certainties but to a Mystery that both satisfies and warms your soul.

The heavens declare the glory of God;
the skies proclaim the work of his hands.

PSALM 19:1

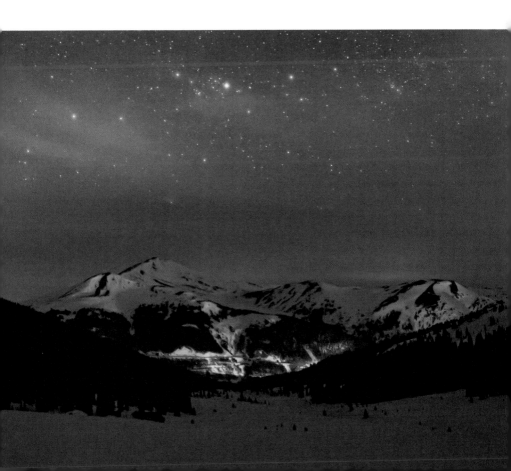

Risk

When my husband, Tom, was climbing Denali, he wrote this:

> Everybody seems to be so afraid of the "slippery
> slope." What if the only way to the summit, or the
> truth we seek, requires traveling a bit along the
> slippery slope? As I see it, we have two choices: to
> learn the skills to safely travel along those danger-
> ous ridges, discover beauty and wonders we never
> imagine, and feel the joy of being alive . . . or forever
> be stuck in the safe, boring, and unimaginative valley
> of certitude and hurl verbal rocks at those climbing
> the ridge.

In one of the first lessons in a mountaineering course, novice climbers learn how to self-arrest if they start sliding down an icy slope. The instructors know that there is always a risk of falling when traveling along ridges with steep embankments on either side. First, they demonstrate what to do by intentionally sliding down a steep mountainside and showing how to use their tools and skills to come to a safe stop. They spend time instructing the climbers and then push each member of the team down the icy slope so they can practice what they've learned. The new climbers are required to follow the directions they've been given and use them in a real-life situation. Taking a proactive approach to "what to do in case of emergency" gives the climbers skills and confidence so that a slide doesn't have to end in disaster.

"Use your pickaxe to dig in, and then relax enough into the slide to allow your body to pivot and come to a stop."

"Don't panic."

"Work to strengthen your core when not on the ice."

"Always stay roped to your teammates."

Overcoming fear of the slippery slopes is essential if we want to experience the exhilaration of reaching the summits that call us. We must travel along dangerous territory on our way to our destination.

There is risk involved.

As we answer the call to grow spiritually, to lean into the path ahead, we will face the anxiety of "what if."

"What if I fall?"

"What if I slide away from what I know is safe?"

"What if I never grow?"

"What if I don't push past my fear of the unknown?"

"What if I spend the rest of my life only criticizing from the bottom of the mountain and never embarking on my own journey?"

Like novice mountaineers, we must learn to face risk by "learning the ropes" if we are to travel safely through unknown territories. We can choose to discover beauty and wonders we could not imagine from the valley below if we hold fast to "him who is able to keep you from falling" (Jude 24 NRSV).

No matter where your climb takes you, hold on to Jesus. He is your guide, your instructor, and your safe traveling partner.

Follow my example, as I follow the example of Christ.

1 CORINTHIANS 11:1

My heart is stirred
to seek you.

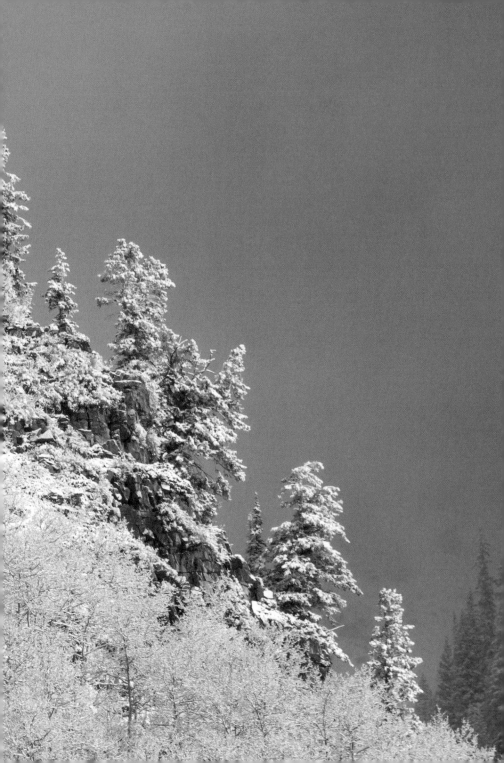

Undaunted

Winter is stuck in shades of melancholy.

Leaden clouds hang sullen and lifeless overhead, unwilling to part ways with one another to let even a momentary ray of sunshine pass through. Shoulder to shoulder, they refuse to budge from the hem of the gloomy landscape. Your mood matches their uninspired gray as you look through your window, your sigh fogging the glass pane. You consider going back to bed for the day, but you know it won't help lift your spirits, which feel just as heavy as the clouds.

It takes enormous mental effort to pull on your outdoor gear—snow pants, sweater, jacket, socks, hat, gloves. You pause at the snowshoes. It's so much work just to take a walk.

But the walls are closing in on you, and your mind has returned to its unhealthy ruts. You know you need the movement of your body to help refresh your brain, and so you strap on the shoes.

Today, you want to believe that there is still *something* undaunted by the cold.

It might as well be you.

The bitter air slaps your cheeks awake as soon as the cabin door closes behind you. Under blue skies and pale sunshine, this winter woodland often looks like a fairy tale. The air is filled with the laughter of people playing and enjoying each other's company. Now, as you step off into the dreary afternoon, everything around you looks as if it's just given up. Pines are bowed in defeat; shrubs look hopeless under the weight of snow. Even the birds cannot muster a song.

Sometimes you have to go out looking for hope.

When will winter end? It feels interminable.

Your shoes crunch across the snow, your arms generating body heat as you walk.

You hear the stream before you find it.

Muffled by mounds of hardened snow, the muted music of gurgling water offers a clue to its whereabouts, like a child who giggles under a blanket while playing hide-and-seek.

You follow the sound, noticing the pattern of tree growth and guessing at the lay of the land beneath your snowshoes. Disguised by white fluff, the riverbank's sudden steepness causes you to nearly lose your balance as you approach the hidden creek.

With its frozen edges wrapped in ice and snow, the stream peeks out from its bundling here and there. Its summer roar has been muffled to a quiet winter chatter.

Found you. You can't help but smile.

Here in this melancholy, the creek proffers a gesture of kindness. *Not all is lost. I'm still here,* she says.

The icy water whispers words that feel providential.

It is as if God is reminding you, *I'm still here too.*

Sometimes you have to go out looking for hope.

Sometimes hope looks like strapping on snowshoes despite the gloom.

Sometimes it looks like a small trickle of water still flowing under winter ice.

Hope may simply be hidden from sight, even when it's nearby. In a

moment of clarity, you realize that sometimes hope can even coexist with ache. Your depression lifts just enough for you to find a spring of life that's still there, still moving, still offering strength in a long winter season.

Your God is undaunted by cold.

> The LORD hears his people when they call to him
> for help. He rescues them from all their troubles.
> The LORD is close to the brokenhearted; he
> rescues those whose spirits are crushed.
>
> PSALM 34:17-18 NLT

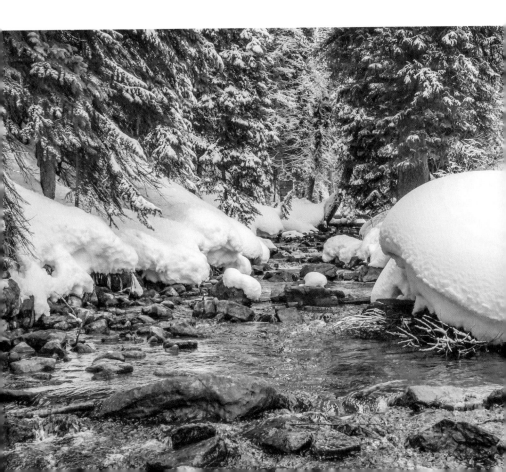

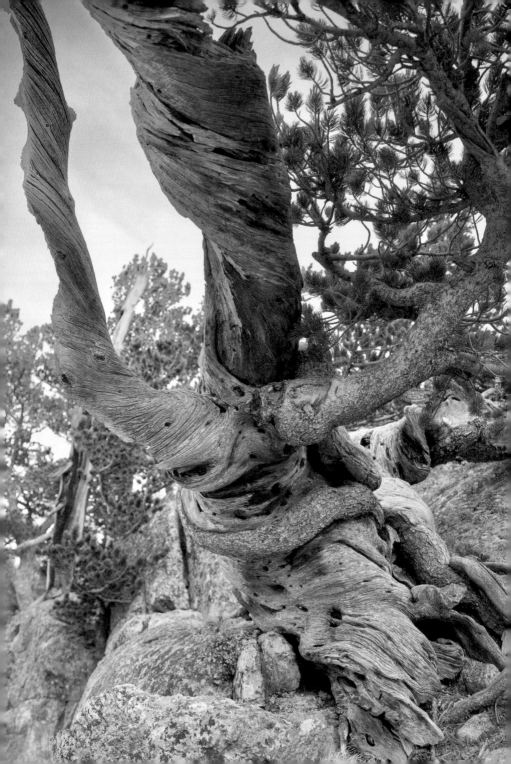

Resilience

High on the windswept mountainside, the lone pine tree bends against the blue sky in a striking pose. Sculpted by centuries of harsh elements, the bristlecone pine stands as a testament to both resilience and design. You gaze at it with the kind of appreciation fine art deserves.

All this tree needs is a crack in the limestone, a split in a small rocky ledge where its seed can lay dormant for years until it finds an opportune moment to begin its nearly imperceptible journey toward the sun. With its ability to absorb microdroplets of moisture, it establishes a unique root system designed for maximum support of the tree's life. As the oldest known organisms on our planet, bristlecone pines are ancient—some exceed five thousand years of age.

The tree's slow growth and dense wood make it resistant to disease, insects, fungi, and even extreme hot, cold, and dry conditions. Some years the growth is so minute that its trunk does not even produce a ring.

And yet it grows.

Standing at the base of this majestic bristlecone, you find yourself overcome with awe—not just for the beauty of this unmatched creation but for its renowned strength.

Slow growth. Deep roots. Dense wood.

There is no place here for impatience.

No space for quick answers or trite words.

There is only the realization that the harshest conditions produce

> "Nothing is wasted."
> —E.V. LUCAS

the strongest growth. There may not be an easy answer to the difficulties in life, but we can rest in the hope that our roots are growing deep and the trials we face will shape us into works of art. Bent and twisted, molded and sculpted, our arms reach upward in testament to our Creator's magnificent care and meticulous design.

> Not only so, but we also glory in our sufferings,
> because we know that suffering produces perseverance;
> perseverance, character; and character, hope.
> And hope does not put us to shame, because God's
> love has been poured out into our hearts through
> the Holy Spirit, who has been given to us.
>
> ROMANS 5:3-5

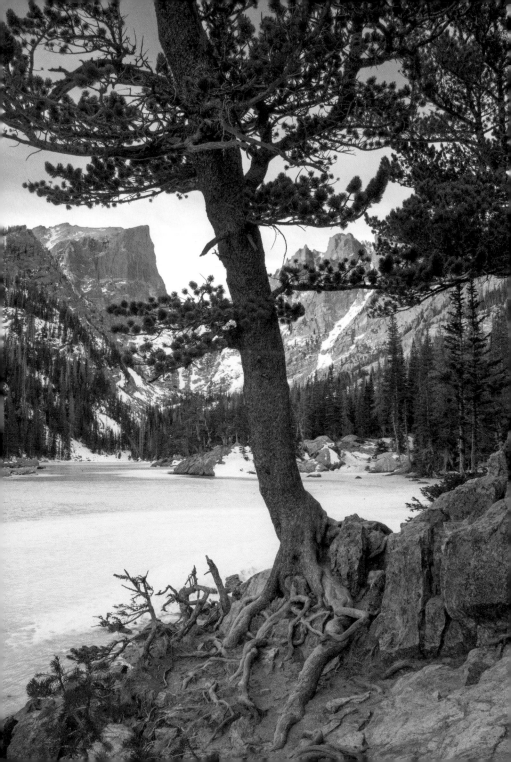

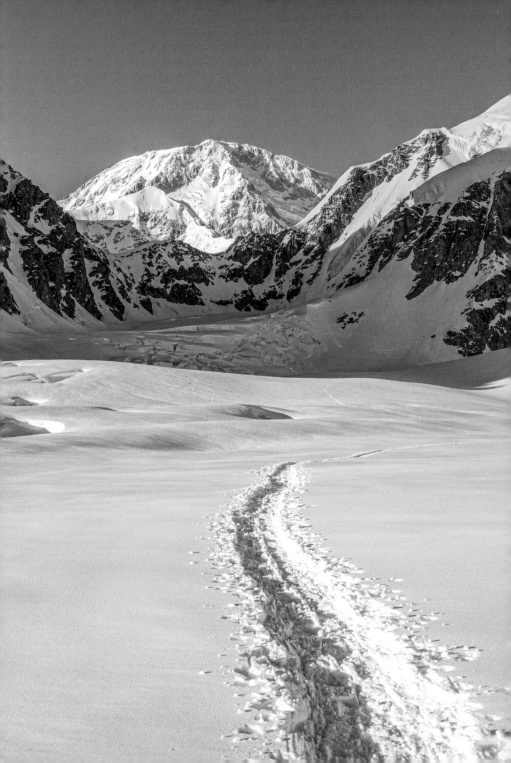

Present

"You are here," says the map at the roadside overlook, indicating your location. The brown metal plaque shows the mountain range you're traversing and a curvy road—a two-lane highway sporting too few guardrails, in your estimation—with an X at the spot you're standing. You look out over the range, but you scarcely notice the glorious scene before you, seemingly painted with an otherworldly air that your phone camera cannot possibly capture.

But the phone stays in your pocket. Your mind is a million miles away, working to unravel strands of worry and regret that are balled up inside. All the mistakes you've made in the past are tangled up with anxiety about the future.

Be present, you tell yourself. You know you need to relinquish the worry that is blinding you to the beauty all around you.

In your mind's eye, a scene from long ago resurfaces, tinged at its edges with the glow of the sunset, and it catches you by surprise. You remember an elementary school teacher who made everyone respond to the roll call with "present" rather than "here." The memory makes you think.

Perhaps that teacher was on to something all those years ago. She knew there is a big difference between "present" and "here."

You can be here without being present.

But you must be present to truly be here.

Being present is not just about our physical location but about the location of our attention and focus. Being present means we are fully

engaged, deeply curious, ready to learn. We are willing to connect with the moment.

Being fully present means we are neither consumed by experiences of the past nor paralyzed by fears of the future. It means laying down our anxieties about what may or may not happen. It leaves our regrets and unanswered questions in the hands of a God who is here and now, who is trustworthy, and who is faithful.

It's not always easy to shift from "here" to "present," but the decision to do so makes all the difference.

God of snow, and mountains, and skies.

God of grace, and beauty, and moments like these.

You, Lord, are the one who is always present to me—attentive, engaged, ready to connect.

May I be present to You always.

Surely I am with you always, to the very end of the age.

MATTHEW 28:20

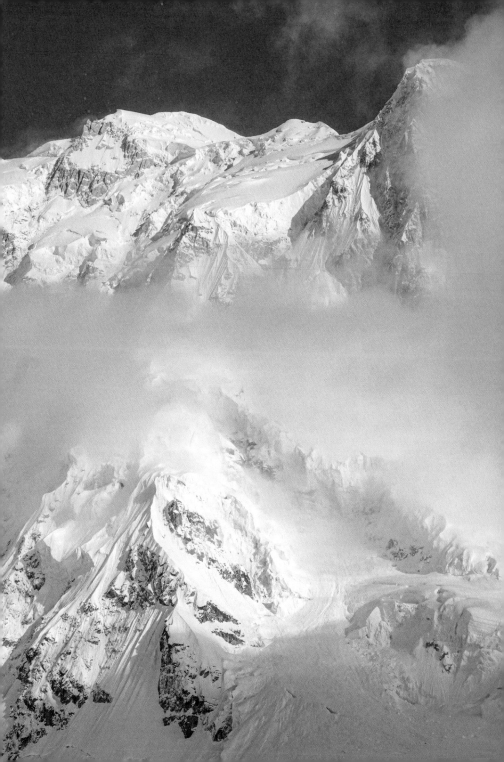

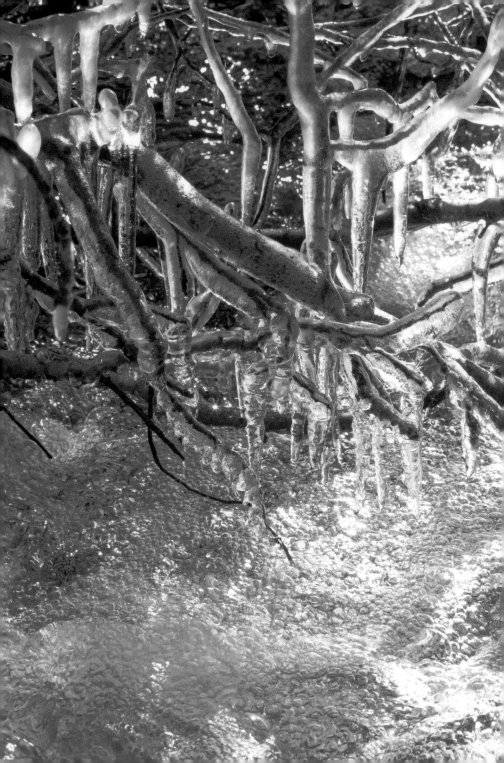

Thaw

The change is barely noticeable.

A few split seconds of pale sunshine.

A fraction of a degree.

The air, still as crisp as it was the day before—and yet.

By midmorning, the distant sun tops the trees and dances along the creek bed, where the ice river lies suspended in motion. A flutter of crimson wings parts the stillness as a cardinal flits from one snow-laden branch to another, perhaps for a better vantage point over the small clearing below.

Phhump.

The smallest of sounds, or was it a sound?

Nothing else moves.

And then, there it is again—*phhump*. But this time you see it: An evergreen sprig rises ever so slightly as a tuft of cotton-white fluff releases its grip, slides down to the tip, and drops to the drift of snow below.

Phhump.

It is the moment of change.

A tiny droplet of water makes its way to the edge of the crystal icicle that's draped like tinsel over a rock and falls with a *tink*. First one, then another—the tinkling beats a hopeful rhythm. Branches above, not quite ready to let go of their burdens, cling to the weight of old snow until at last the load slips free. *Phhump. Tink, tink, tink, phhump.*

> To stand at winter's edge and welcome the thaw so long in coming is to feel your own heart begin to beat once more.

Another flutter of wings, and a sprinkling of snowdrops falls from a hidden perch.

To stand at winter's edge and welcome the thaw so long in coming is to feel your own heart begin to beat once more. Frozen in time and hardened by past hurt, it is being warmed in the sun of grace.

Each droplet, each clump of snow finds its way to the river below, tumbling with delight in the freedom of new life. What was hardened, motionless, stiffened by the elements will now nourish the world with healing. The places of grief alight with joy.

Here in this moment of snowmelt, you choose to let go. You choose to stand in the sun for a few seconds longer. You lift your face in surrender, hands in release.

You are becoming free.

Perhaps the thaw will bring a flood of unrestrained joy, pushing through logjams and dislodging boulders in its path. Or perhaps there will yet be cold nights that will freeze what has once thawed, and each day will require starting over. Standing in the sun. Allowing droplets to re-form. You must rerelease the pain. Each new melt gets easier.

Eventually all will give way to grace. Every tiny stream will nourish verdant meadows and forests, and your heart will overflow with abundant life.

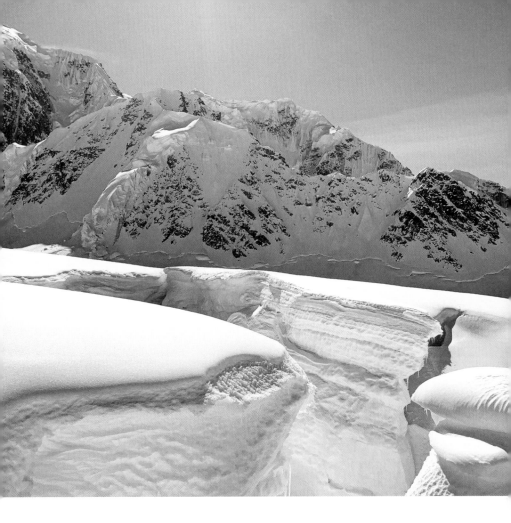

He showers snow like wool;
He scatters the frost like ashes.
He hurls His ice as fragments;
Who can stand before His cold?
He sends His word and makes them melt;
He makes His wind blow, and the waters flow.

PSALM 147:16-18 NASB

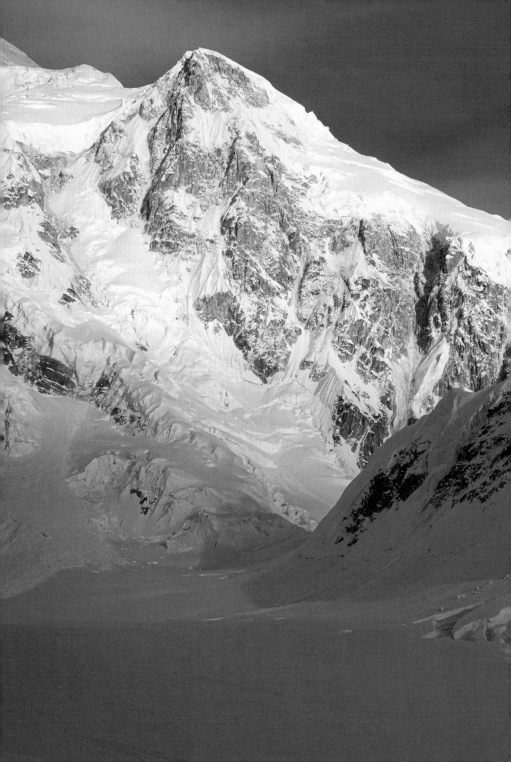

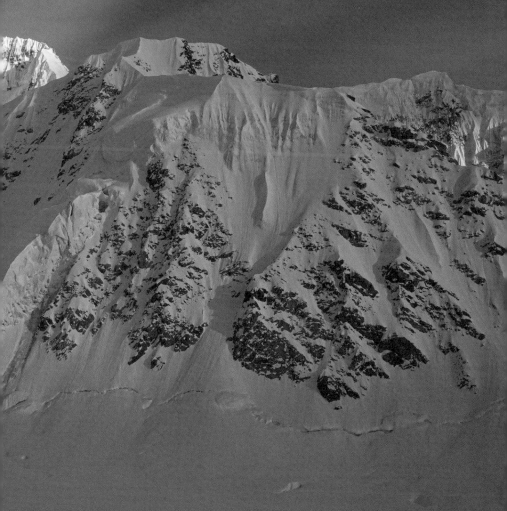

Creator God,
Your fingerprints are
everywhere.

The photos in this book were taken in the Rocky Mountains and the Alaska Range. Some of the modern roads and trails we used follow ones that were originally created by the native tribes that inhabited these sacred spaces long before the first Europeans arrived. We want to honor the Apache, Arapaho, Cheyenne, Comanche, Shoshone, and Ute tribes of the Rockies; and the Ahtna, Dena'ina, Koyukon, Kuskokwim, and Tanana tribes of Alaska, whose ancient lands we traveled, explored, and photographed for this book.

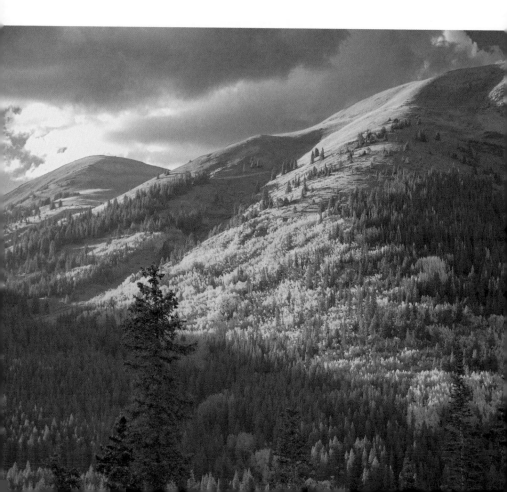

Notes

1. Francis Bacon, *Of the Proficience and Advancement of Learning, Divine and Human* (London: J.F. Dove, 1828), 53. Originally published in 1605.
2. C.S. Lewis, *The Last Battle* (New York: Harper Trophy, 2000), 196.
3. John O'Donohue, *To Bless the Space Between Us: A Book of Blessings* (Colorado Springs, CO: Convergent Books, 2008), 9.
4. Frederick Buechner, *Wishful Thinking: A Theological ABC* (New York: HarperCollins, 1973), 95.
5. "The Daily Examen," IgnatianSpirituality.com, https://www.ignatianspirituality.com/ignatian-prayer/the-examen/.
6. Maltbie Babcock, "This Is My Father's World," 1901.
7. John Muir, *Nature Writings: The Story of My Boyhood and Youth, My First Summer in the Sierra, the Mountains of California, Stickeen, Selected Essays.* Cited in Stephen K. Hatch, *The Contemplative John Muir* (Lulu, 2012), 186.
8. "Bluebell," Woodland Trust, https://www.woodlandtrust.org.uk/trees-woods-and-wildlife/plants/wild-flowers/bluebell/.
9. The Book of Common Prayer (1979), 358-59, bcponline.org.
10. Cornelius Plantinga Jr., *Not the Way It's Supposed to Be: A Breviary of Sin* (Grand Rapids, MI: Eerdman's, 1995), 10.
11. Saint John of the Cross, *Dark Night of the Soul,* http://www.carmelitemonks.org/Vocation/DarkNight-StJohnoftheCross.pdf.
12. Wendell Berry, "The Peace of Wild Things," https://onbeing.org/poetry/the-peace-of-wild-things/.
13. T.S. Eliot, from "Little Gidding," *Four Quartets* (Faded Page e-book edition, 2019), 53. Originally published in 1943.

About the Authors

Growing up in the Pacific Northwest, **Rachel Ridge** fell in love with the Olympic Mountains. Nature is the space in which she is most at peace—and most drawn to her Creator. Her books *Flash* and *Walking with Henry* establish her place as a writer about nature, God's creatures, and listening for His voice. Rachel and Tom have been married for almost forty years and have three grown children and five grandchildren.

Photographer **Tom Ridge** developed a love of the outdoors exploring rivers and lakes in his boyhood home of Minnesota. Today, his passion for mountain climbing, backpacking, and photography takes him to remote landscapes, where he captures the beauty of nature and tells stories through the lens of his camera.

Special thanks to our son, **Grayson Ridge**, Tom's climbing and photography partner. It's an honor to explore landscapes, work out technical issues, suffer through miserable conditions, and climb incredible heights together. Grayson is credited with the photos on pages 47, 51, 133, 169, and 187.